Photography by Alison Poustie

Copyright © 1982 by Alice Starmore
Library of Congress Catalog Card Number 81-70273
ISBN 0-442-27835-7

Printed in Great Britain

First published in Great Britain in 1982 by
Bell & Hyman Limited, London

Published in the United States in 1982 by
Van Nostrand Reinhold Company
135 West 50th Street
New York, NY 10020

16 15 14 13 12 11 10 9 8 7 6 5 4 3 2 1

Designed by Colin Lewis

Scandinavian Knitwear

30 original designs
from traditional patterns

Alice Starmore

VNR VAN NOSTRAND REINHOLD COMPANY

NEW YORK CINCINNATI TORONTO LONDON MELBOURNE

Acknowledgements

The research for this book was conducted during 1978 in Norway, Sweden and Finland, while on a Travelling Fellowship from the Winston Churchill Memorial Trust.

I would like gratefully to acknowledge the assistance of:

The staff of the Swedish Institute, Stockholm.
Inga Winzell, Nordiska Museet, Stockholm.
Aagot Noss, Norsk Folkemuseum, Oslo.
Marie Walden, Ministry of Foreign Affairs, Helsinki.
Pirjo Varjola, National Museum, Helsinki.

With special thanks to Major General Anthony Lascelles, Director General (now retired), Winston Churchill Memorial Trust.

Accessories used in photographs
Norskä (page 15): Boots from Camouflage, Victoria St, Edinburgh.
Selbu (page 22): Puppets by Pelham Puppets Ltd, The Ugly Duckling, Edinburgh.
Trøndelag jacket (page 25): Shirt and trousers from Buzzini, Rose St, Edinburgh.
Dale (page 32): Skirt from Camouflage, Edinburgh.
Halland (opposite page 16): Blouse and trousers from Camouflage, Edinburgh.
Delsbø sweater (opposite page 80): Breeches from Camouflage, Edinburgh.
Baltic (opposite page 33): Shirt from Camouflage, Edinburgh.
Ruska (page 100): Shirt and trousers from Buzzini, Edinburgh.
Estonia cardigan (page 113): Trousers from Pete Clark, Victoria St, Edinburgh.

The wool for all the knitted garments was kindly supplied by *Hayfield Ltd*, Hayfield Mills, Glusburn, Keighley, West Yorkshire, and *Sirdar Ltd*, PO Box 31, Alverthorpe, Wakefield, Yorkshire.

The garments shown in the historical photographs on pages 49, 87 and 88 are from the National Museum, Helsinki.

Contents

Foreword

This book is the result of a journey of some three thousand miles through Norway, Sweden and Finland – the most northerly and remote corner of Europe. The funding for the journey came from the Winston Churchill Memorial Trust who awarded me a Travelling Fellowship, but the motivation for it was altogether more difficult to define. I knew of the general excellence of Scandinavian design, and as a knitwear designer I had always been aware of something called 'Scandinavian knitting', although my image of what it amounted to was never particularly clear. In short, I knew that something existed and I set out to discover what it was.

I planned the journey as a wide-ranging circular tour, beginning in Stockholm and finishing in Helsinki, with the half-way mark well beyond the Arctic Circle in the northern reaches of Lapland. Along the way I visited major national museums, small folk museums in out of the way places, and handicraft associations of all kinds, collecting and photographing patterns and talking to the people who worked with them. The results of my research proved to be astonishing. The sheer amount of material took me completely by surprise and indeed my first general discovery about Scandinavian knitting was that there is a vast amount of it. It exists in more variety and in a better state of preservation than the knitting of most other countries.

The main reason for this is that the tradition of folk costume is more alive in Norway, Sweden and Finland than in the rest of Europe. Furthermore, the costumes are widely different in each separate region, and there is much present-day interest and feeling for this local tradition. Among the knitted garments, it has usually been a case of the survival of the most elaborate. The items which remain preserved do not tend to be everyday garments, but those knitted for some particular reason – Sunday clothes for example, or clothes worn for festivals. Festivals had a great significance in Scandinavian village life and the people dressed for the occasion, whether it was religious or a celebration for a birth or a wedding. In all three countries there were professional knitters who would be commissioned to create particular garments for special occasions, often with initials and a date knitted in.

Although this makes for certain similarities in the knitting of Norway, Sweden and Finland, the individual styles of these countries have very distinct differences. What these differences are and how they fit together will be seen later. However, this is not intended to be a history book. Its purpose is meant to be practical – for people who love to knit. I have used some of the patterns which I discovered on my travels as inspiration for thirty of my own original designs, and in so doing I have set out to achieve two main objectives.

First, as a designer I want my own work to be true to the idea of Scandinavian design. One of the reasons for the excellence of their design is that in Scandinavia the traditional handicraft virtues have been preserved in the modern manufacturing processes. In Britain and many other countries, there has always been a wide gap between traditional craft skill and mass production, so good design is often expensive. In Scandinavia, not only is the relationship between designer

8

and industry much better established, but the designer is usually very conscious of craft tradition. This is one reason why the Scandinavians have managed to keep the essence of their folk culture alive, without producing work that is in any way 'folksy' or ethnic. I have sought to do the same in designing the collection of garments for this book. Their inspiration lies in past tradition and skill, but the result is intended to provide a balance between the fashionable and the classic.

Second, I wanted to produce a book for the competent knitter – something that will extend your skill. Many knitters avoid colourwork, when all it really takes is a little more concentration to produce something truly worthwhile. You do not need to be an expert in order to attempt most of these patterns, but you do need to make that little extra effort. In order to tempt you into accepting the challenge I have sought to create designs which are special and distinctive.

Your reward? Something interesting to knit and something extra-special to wear.

How to use this book

Tension (or gauge)

Tension relates to the number of stitches and rows to a given measurement. The size of every garment is based on this measurement. It is therefore *essential* that you work a tension sample using the correct type of yarn, needle size, and stitch (st.st or pattern, as stated) before commencing any garment. It is wrong to assume that you will knit to the same tension as that given, and if you are even half a stitch out, your garment could end up as much as 5cm too large or small.

Once you have worked your tension sample, place it on a flat surface and secure it with pins, being careful not to stretch it. Then lay a firm rule across the sample, mark with pins the tension measurement given in the pattern, (e.g. 5cm [2ins]) and count the exact number of stitches between the pins. Then measure the rows in the same manner. If your stitches and rows are exactly the same as those given, then it is safe to begin. If you have too few stitches and rows, this means that your tension is too loose. To correct this, work a sample using a smaller size of needle. If you have too many stitches and rows, this means that your tension is too tight. To correct this, work a sample using a larger size of needle.

It is not a reflection on your skill if your tension is looser or tighter than that given in the pattern, and it doesn't matter if you end up using much smaller or larger needles. Once you achieve the given tension, you will knit a perfect garment.

Reading the charts

The colour designs are set out in charts on graph paper. Each colour is represented by a different symbol on the chart and a key to these symbols is given alongside the chart.

One square represents one stitch and one row of squares represents one complete row of knitting.

The first and every following odd numbered row is worked from right to left, and the second and every following even numbered row is worked from left to right.

The pattern stitches are repeated a specified number of times across the work, and the edge stitches, which are not repeated, are given at each side of the pattern stitches.

Full instructions on using each chart are given in the text. (References to the different numbers of edge stitches needed for different sizes are separated by oblique lines.)

Abbreviations

and American equivalents for British terms

alt. alternate (USA every other)
approx. approximately
asterisk * This indicates that the instructions following the symbol are to be repeated a specified number of times.
beg beginning
C Contrast
cast off USA: bind off
cm centimetre

DC Double Crochet (USA: single crochet)

foll following

g gramme

ins inches

k knit

knit up Insert the point of the right hand needle from the front to the back of the fabric, one complete stitch in from the edge. Put the yarn under then over the needle, pull the loop on the needle through the fabric quite loosely, and leave it on the needle, thus forming one stitch.

m1 make one. Lift the running thread onto the tip of the left hand needle, so that it lies over the needle from the left, behind, to the right, in front; then insert the right hand needle into the back of this thread, to knit a new stitch.

mm millimetre

MS Main Shade

p purl

psso pass slip stitch over. Insert the tip of the left hand needle into the stitch just slipped and draw this stitch over the stitch just knitted, and over the tip of the right hand needle, and off the needle.

rep repeat

shape top USA: shape cap

sl slip. Pass the stitch(es) from the left to the right hand needle without working. Always insert the right hand needle into the stitch to be slipped *as if to purl* unless otherwise stated.

ssk slip, slip, knit. Slip the first and second stitches *knitwise*, one at a time, then insert the tip of the left hand needle into the *fronts* of these 2 stitches from the left, and knit them from this position.

st.st stocking stitch (USA: stockinette stitch)

st(s) stitch(es)

tbl through back loops

tension USA: gauge

tog together

yb yarn back. The yarn is carried across behind the stitch(es).

yf yarn forward. The yarn is carried across in front of the stitch(es).

yo yarn over. Take the yarn over the top of the needle once before working the next stitch. If the next stitch is to be knitted, then the yarn is taken over the top of the right hand needle, to the back; if the next stitch is to be purled, then the yarn is taken over the top of the right hand needle and then under the needle to the front. The yo is counted as a separate stitch on the return row.

KNITTING NEEDLES

Metric (in mm)	Britain	USA
9	000	15
$8\frac{1}{2}$	00	13
8	0	–
$7\frac{1}{2}$	1	11
7	2	$10\frac{1}{2}$
$6\frac{1}{2}$	3	10
6	4	9
$5\frac{1}{2}$	5	8
5	6	7
$4\frac{1}{2}$	7	6
4	8	5
$3\frac{1}{2}$ and $3\frac{3}{4}$	9	4
$3\frac{1}{4}$	10	3
$2\frac{3}{4}$ and 3	11	2
$2\frac{1}{2}$	12	1
$2\frac{1}{4}$	13	0
2	14	00

CROCHET HOOKS

Metric (in mm)	Britain	USA
$7\frac{1}{2}$	–	–
7	2	$K/10\frac{1}{4}$
$6\frac{1}{2}$	3	–
6	4	J/10
$5\frac{1}{2}$	5	I/9
5	6	H/8
$4\frac{1}{2}$	7	G/6
4	8	F/5
$3\frac{1}{2}$	9	E/4
$3\frac{1}{4}$	10	D/3
$2\frac{3}{4}$ and 3	11	C/2
$2\frac{1}{2}$	12	B/1
$2\frac{1}{4}$	13	–
2	14	–

American equivalents for British yarns

4-ply light weight

DK (double knitting) sport weight

light weight mohair light weight hairy

chunky heavy weight

Norway
The Geometric Art

Mention the words 'Scandinavian style' to most knitters and the chances are that they will immediately visualise one of those unmistakable Norwegian ski-sweaters which are so widely exported throughout Europe and the USA. In common knitting language 'Norwegian' and 'Scandinavian' amount to one and the same thing. The time has come to explode some celebrated myths.

First, although Norwegian knitwear is famous, this doesn't mean that it is in any way superior to or more highly developed than the knitting of Sweden or Finland. What it does mean is that Norway has a modern, well established and well organised hand-knitting industry with a keen eye for export orders.

Second, when we speak of a craft as being traditional, we automatically think in terms of something that stretches back into the mists of time, but in the case of those marvellous Norwegian sweaters this is by no means true. In fact, what we regard today as traditional Norwegian knitting had its origins less than two hundred years ago.

Knitted items dated much earlier have been discovered, but they have always been the remnants of mittens or the feet of stockings, and any decoration has been worked in embroidery. The embroidered decoration is often beautiful, colourful and elaborate, but the knitting is invariably plain, and it was not until the early nineteenth century that actual patterned knitting started to appear in Norway, replacing hand-woven stockings and caps. Patterned sweaters, styled like the jackets of the folk costume, appeared about the same time. However, in the case of something beautiful, worthwhile and requiring great skill, what does it matter whether it was developed one hundred or one thousand years ago?

Although the craft itself is not ancient, the design elements included in it are very old indeed. They had been used in hand-weaving (as well as in embroidery, woodcarving and metalwork) for hundreds of years. If we are looking for the common denominator in Scandinavian knitting, then I believe it is rooted in this close relationship between woven and knitted textiles. In each of the Scandinavian countries weaving (as a decorative art) came first, and when pattern knitting was eventually developed it was from weaving that the traditional design elements were taken.

Textiles have been exported and imported throughout history and there has been a greater cultural exchange in the case of woven textiles than in any other craft. Designs and motifs were frequently copied, particularly in the Renaissance period when a large number of textile pattern books were in circulation. All of Scandinavia came under these same international influences in textile design, which they then transferred to their knitting. This explains why the patterns used in all three countries have many elements in common.

However, environmental factors and, above all, the characteristics of the local people varied widely from one country to another. As a result, although the same basic motifs and designs often reappear, each area interprets them in its own, quite different, way.

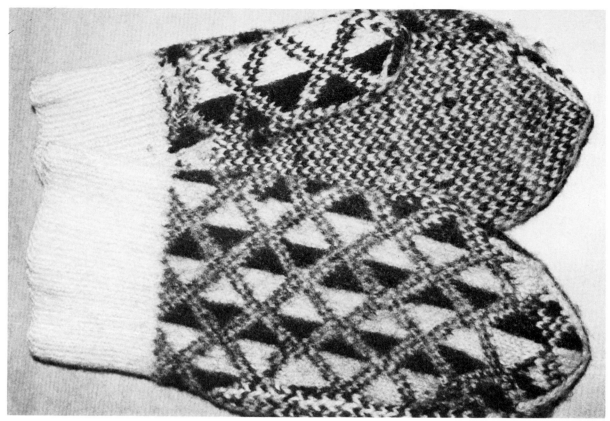

Norwegian mitten, used for Trøndelag jacket (page 25).

What then are the main design elements and motifs of Norwegian hand-knitting? There are three major groups, the first being the cross, the diamond, the X and the swastika. Another group consists of human figures, animals and birds, while the third includes many floral motifs, the most common being the eight-petal rose which occurs time and time again in garments of different types. All of these motifs are very old and all have been used for centuries in textile art throughout Europe and many other countries. The Norwegians, however, have incorporated them into their knitting in a unique and distinctive way.

The key phrase to describe Norwegian knitting is 'simple and effective'. The design elements have been taken and arranged in a clean, geometric style involving regular, repetitive patterns and clear, distinct borders. Their use of colour is also simple, and is limited to no more than two colours – a dark ground and a light contrast. Today these colours will usually be black and white, but traditionally the undyed yarn of two different breeds of sheep was used, one dark brown and the other a lighter, creamy colour.

Norskä
Woman's mini-dress

Norskä is so-called because it embodies several typical Norwegian qualities. The Flea Pattern on the body of the dress is used throughout the country, and represents an excellent example of something extremely simple used to great effect. The borderwork features the X and diamonds used on many sweaters, while the shape of the garment – a straight dress with square sleeves – accentuates the geometric nature of the borders. The use of simple black and white is not only typical, but also adds to the bold geometric theme.

Materials
12 (14) 50g balls in MS.
3 (4) 50g balls in C.
1 pair each 3¾mm and 4mm needles.

The yarn used in this garment is Sirdar 'Majestic' DK in Black with White.

Measurements
To fit bust: 81 to 86 (91 to 97)cm [32 to 34 (36 to 38)ins]
Actual width: 94 (104)cm [37 (41)ins]
Length from top of shoulder: 86 (91)cm [34 (36)ins]
Sleeve seam: 41 (43)cm [16(17)ins]

Tension
11½ sts and 14 rows to 5cm [2ins] measured over st.st using 4mm needles.

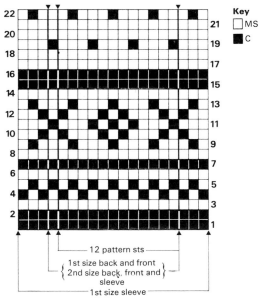

Key
☐ MS
■ C

12 pattern sts
{ 1st size back and front
2nd size back, front and }
sleeve
1st size sleeve

Chart A

Back
* With 3¾mm needles and MS, cast on 109 (121) sts. Knit 8 rows in garter st. Change to 4mm needles and begin pattern as follows:
 k6 in MS, then joining in and breaking off colours as required, work rows 1 to 16 of pattern from Chart A, repeating the 12 pattern sts 8 (9) times across, and working the last st on k rows and the first st on p rows as indicated, k6 in MS. Continue in this manner (working the 6 sts at each side in garter st) until the 16 row border pattern is complete. Then work repeats of rows 17 to 22 across all sts. Continue in this manner until back measures 70 (75)cm [27½ (29½)ins], with right side facing for next row.**

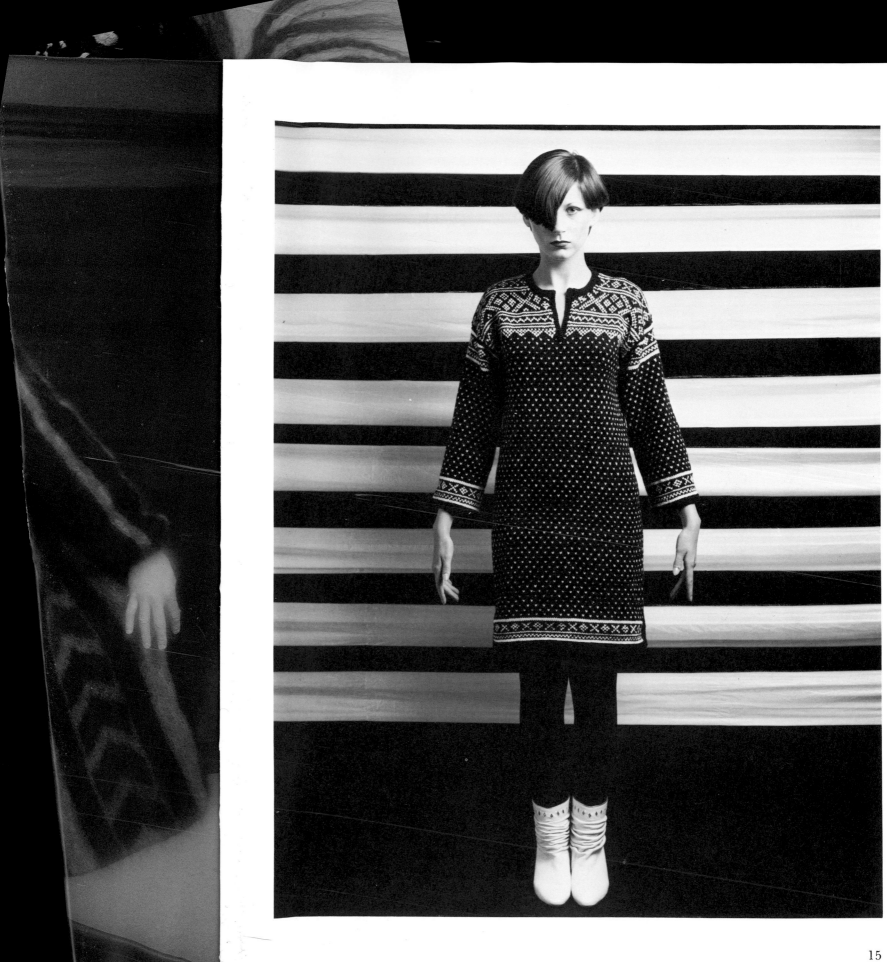

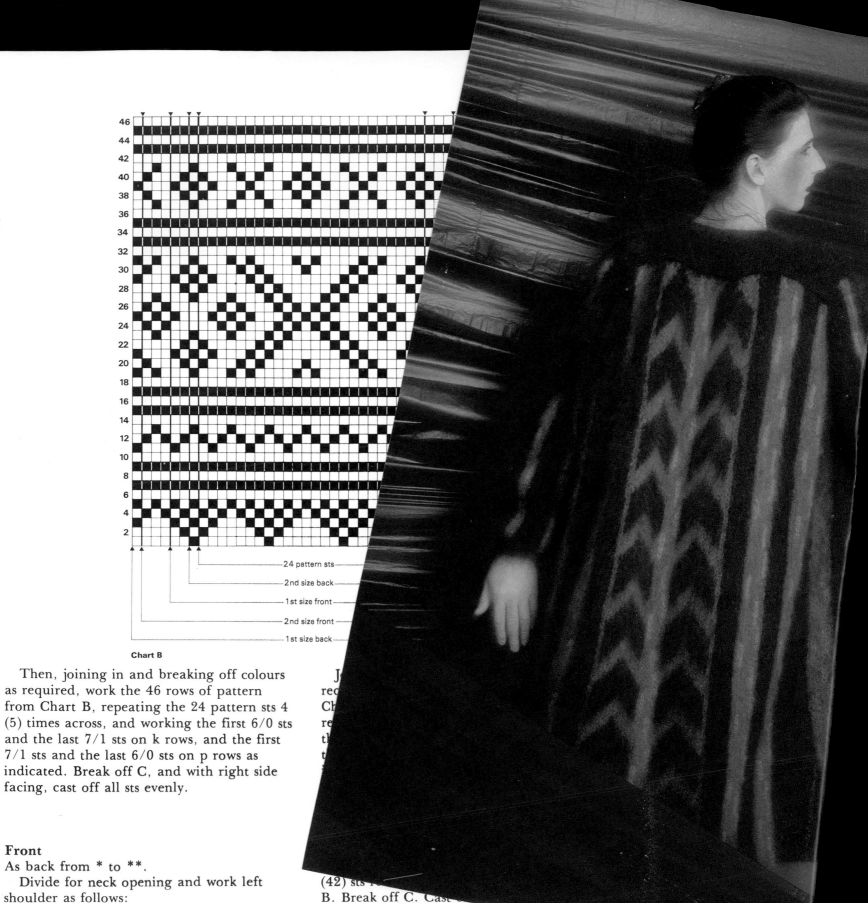

Chart B

Then, joining in and breaking off colours as required, work the 46 rows of pattern from Chart B, repeating the 24 pattern sts 4 (5) times across, and working the first 6/0 sts and the last 7/1 sts on k rows, and the first 7/1 sts and the last 6/0 sts on p rows as indicated. Break off C, and with right side facing, cast off all sts evenly.

Front

As back from * to **.

Divide for neck opening and work left shoulder as follows:

(42) sts
B. Break off C. Cast

OPPOSITE: Halland (page 51).

Right shoulder With right side facing, pick up the sts from spare needle and cast off the first (centre) st. Join in C and work pattern from Chart B as left shoulder, reversing all shapings and beginning neck shaping on row 26 of Chart B.

Sleeves

With 3¾mm needles and MS, cast on 91 (97) sts. Knit 8 rows in garter st. Change to 4mm needles, join in C and breaking off colours as required, work the pattern from Chart A repeating the 12 pattern sts 7 (8) times across, and working the first 3/0 sts and the last 4/1 sts on k rows, and the first 4/1 sts and the last 3/0 sts on p rows as indicated. Work rows 1 to 16 of Chart A once only, and thereafter work repeats of rows 17 to 22. Continue in this manner until sleeve measures 34 (36)cm [13¼ (14¼)ins], with right side facing for next row.

Then joining in and breaking off colours as required, work rows 1 to 16 of Chart A once more. Break off C, and with MS knit 4 rows in garter st. Cast off evenly.

Finishing

Press all pieces using a warm iron and damp cloth. Join back and front at shoulder seams.

Neckband With right side of work facing, 3¾mm needles and MS, and beginning at top right of neck, knit the 6 sts from length of yarn, knit up 16 sts along right side of neck, knit up 30 (34) sts across back neck, knit up 16 sts along left side of neck, then knit the 6 sts of left neck from length of yarn. Knit 6 rows in garter st. Cast off evenly.

Left front opening With right side of work facing, 3¾mm needles and MS, and starting at top edge, knit up 28 sts along left front opening. Knit 4 rows in garter st. Cast off evenly.

Right front opening As left but starting at bottom end of opening.

Press front openings gently. Cross right opening over left and catch down neatly in position. Sew sleeves to body, matching centre of sleeve to shoulder seam. Press seams. Sew up side seams, leaving garter st edgings open. Sew up sleeve seams. Press seams.

OPPOSITE: Dalarna (page 61).

17

Fana
Woman's sweater

Norwegian knitting is reasonably unified in style throughout the country, but certain areas have become famous for particular patterns or garments. Fana for example, just south of Bergen, is well known for its two-colour sweaters distinguished by a broad band of eight-petal roses across the shoulders and around the cuffs. The rest of the sweater is decorated either by the Flea Pattern or by small geometric designs. These sweaters were often knitted from hem to waist in a light-coloured yarn with no pattern whatsoever, the idea being that this part of the sweater would be tucked into your trousers. I have used this feature in order to adapt the sweater as a woman's garment, shaping the sides and emphasising the waistline, in contrast with the straight, geometric lines of Norskä. Instead of traditional black and white, I have used soft green on a cream background to create a more feminine, romantic look.

Materials
11 (12, 12, 13) 25g balls of Standard 4-Ply yarn in MS.
2 (2, 3, 3) 25g balls of Standard 4-Ply yarn in C.
1 pair each 3mm and 3¼mm needles.

Measurements
To fit bust: 81 (86, 92, 97)cm [32 (34, 36, 38)ins]
Length from top of shoulder: 61 (63, 66, 68)cm [24 (25, 26, 26¾)ins]
Sleeve seam: 44 (45, 46, 46)cm [17¼ (17¾, 18, 18)ins]

Tension
14 sts and 17 rows to 5cm [2ins] measured over st.st using 3¼mm needles.

Back
* With 3mm needles and MS, cast on 120 (128, 136, 140) sts.
k2, p2 rib for 5cm [2ins].
Change to 3¼mm needles and working in st.st, decrease 1 st in the centre of next row.

Continue straight for 5 rows, then shape sides by decreasing 1 st at each end of next and every foll. 6th (6th, 6th, 8th) row until 105 (113, 119, 127) sts remain.

Continue straight until back measures 20 (20, 22, 24)cm [8 (8, 8½, 9½)ins], with right side facing for next row.

Join in C and work the 14 rows of Chart A once, repeating the 14 pattern sts 7 (8, 8, 9) times across, and working the first 3/0/3/0 sts and the last 4/1/4/1 sts on k rows, and the first 4/1/4/1 sts and the last 3/0/3/0 sts on p rows as indicated.

Break off C and working in MS, increase 1 st at each end of next row. Purl 1 row in MS.

Join in C and work the 8 rows of pattern from Chart B once, repeating the 4 pattern sts 26 (28, 30, 32) times across, and working the first 1/1/0/0 sts and the last 2/2/1/1 sts on k rows, and the first 2/2/1/1 sts and the last 1/1/0/0 sts on p rows as indicated.

Keeping continuity of pattern and working repeats of rows 3 to 8 as indicated, increase 1 st at each end of next and every foll. 6th row

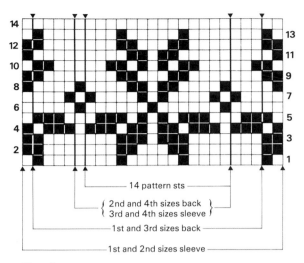

Chart A

Key
☐ MS
■ C

14 pattern sts

2nd and 4th sizes back
3rd and 4th sizes sleeve

1st and 3rd sizes back

1st and 2nd sizes sleeve

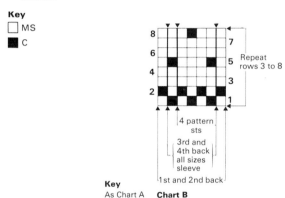

Repeat rows 3 to 8

4 pattern sts

3rd and 4th back all sizes sleeve

1st and 2nd back

Key
As Chart A **Chart B**

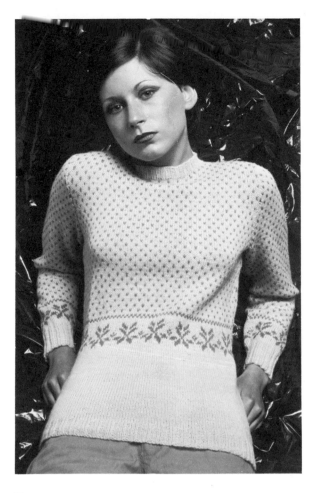

until there are 115 (121, 127, 135) sts. Continue straight until back measures 43 (44, 46, 47)cm [17 (17½, 18, 18½)ins], with right side facing for next row.

Shape armholes Keeping continuity of pattern, cast off 6 sts at beg of next 2 rows. Then decrease 1 st at each end of next and every foll. alt. row until 87 (93, 97, 103) sts remain. **

Continue straight until back measures 61 (63, 66, 68)cm [24 (25, 26, 26¾)ins], with right side facing for next row.

Shape shoulders Keeping continuity of pattern, cast off 5 (6, 6, 7) sts at beg of next 2 rows. Cast off 7 (7, 8, 8) sts at beg of next 4 rows. Then cast off 5 (6, 6, 6) sts at beg of next 2 rows. Place the remaining 39 (41, 41, 45) sts on a length of yarn.

Front
As back from * to **.

Continue straight until front measures 57 (59, 61, 63)cm [22½ (23¼, 24, 24¾)ins], with right side facing for next row.

Shape neck Pattern 34 (36, 38, 40) sts. Place the remaining sts on a spare needle. Turn, and work left shoulder as follows:

Cast off 2 sts at beg (neck edge) of next and foll. alt. row. Work 1 row. Then decrease 1 st at neck edge of next and every foll. alt. row until 24 (26, 28, 29) sts remain. Continue straight until armhole corresponds in length with back, at shoulder edge and with right side facing for next row.

Shape shoulder Cast off 5 (6, 6, 7) sts at beg of next row. Work 1 row. Cast off 7 (7, 8, 8) sts at beg of next and foll. alt. row.

19

Work 1 row. Then cast off the remaining 5 (6, 6, 6) sts.

With right side of work facing, place the next (centre front) 19 (21, 21, 23) sts on a length of yarn. Join colours to the remaining 34 (36, 38, 40) sts of right shoulder and work as left, reversing all shapings.

Sleeves

With 3mm needles and MS, cast on 52 (52, 56, 56) sts.

k2, p2 rib for 6cm [2½ins].

Change to 3¼mm needles and work 3 rows in st.st, increasing 1 st at beg of the first row.

Join in C and work the 14 rows of pattern from Chart A once, repeating the 14 pattern sts 3 (3, 4, 4) times across, and working the first 5/5/0/0 sts and the last 6/6/1/1 sts on k rows, and the first 6/6/1/1 sts and the last 5/5/0/0 sts on p rows as indicated. Increase 1 st at each end of row 9 and row 14 of pattern. Break off C and work 2 rows in MS.

Join in C and work the 8 rows of pattern from Chart B once, working the 4 pattern sts 14 (14, 15, 15) times across, and working the last st on k rows and the first st on p rows as indicated.

Keeping continuity of pattern, increase 1 st at each end of row 4 of pattern, and every foll. 5th row, working repeats of rows 3 to 8 as indicated, until there are 85 (87, 89, 91) sts.

Continue straight until sleeve measures 44 (45, 46, 46)cm [17¼ (17¾, 18, 18)ins], with right side facing for next row.

Shape top Keeping continuity of pattern, cast off 6 sts at beg of next 2 rows. Then decrease 1 st at each end of next and every foll. alt. row until 33 (33, 35, 35) sts remain. Then decrease 1 st at each end of every row until 21 sts remain. Cast off.

Finishing

Omitting ribbing, press all pieces using a warm iron and a damp cloth. Sew front to back at left shoulder seam. Press seam.

Neckband With right side of work facing, 3mm needles and MS, pick up and knit the 39 (41, 41, 45) sts from back neck, knit up 19 (19, 21, 22) sts down left neck edge, pick up the 19 (21, 21, 23) sts from front neck, knit up 19 (19, 21, 22) sts up right neck edge. 96 (100, 104, 112) sts.

k2, p2 rib for 10 rows. Cast off evenly.

Sew up right shoulder seam and press. Sew up side and sleeve seams and press. Insert sleeves and press gently.

Selbu
Child's pants and sweater

The other area, besides Fana, noted for its two-colour knitting is Selbu, a few miles inland from Trondheim and the centre of a thriving home knitwear industry. While Fana has specialised in sweaters, Selbu is famous for its mittens. The palms of the mittens will often be completely covered by a pattern based on squares or triangles (again, note the accent on the geometric), while on the back there will be a large, single motif. A human figure or perhaps a reindeer will often be used, although the ubiquitous eight-petal rose and other floral motifs are dominant. Wrists and cuffs are ornamented with abstract two-colour work such as a running or a chevron wave, often including a lace stitch design as well.

I chose cream and blue for my interpretation of 'Selbu' – a little boy's sweater and pants that combines almost everything that can be regarded as typically Norwegian. There is the Flea Pattern on the body of the sweater, the geometric borders on sleeves and legs, and finally, in pride of place on the bib, there is the motif from Selbu. This particular abstract motif is typical, although not in common use today.

Materials
4 25g balls of Standard 4-Ply yarn in MS.
4 25g balls of Standard 4-Ply yarn in C.
1 pair each $2\frac{3}{4}$mm and $3\frac{1}{4}$mm needles.
2 buttons in MS and 2 buttons in C.

Measurements
Age 2 to 3 years
To fit chest: 56cm [22ins]
Sweater length from top of shoulder: 33cm [13ins]
Sleeve seam: 23cm [9ins]
Waist to crotch: 23cm [9ins]

Tension
14 sts and 17 rows to 5cm [2ins] measured over st.st using $3\frac{3}{4}$mm needles.

PANTS

First leg
* With $2\frac{3}{4}$mm needles and MS, cast on 69

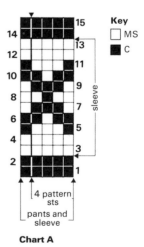

Chart A

sts. k1, p1 rib for 6 rows, the last st on right side rows having a k st, and the first st on wrong side rows having a p st.

Change to $3\frac{1}{4}$mm needles and joining in C, work the 15 row border pattern from Chart A, repeating the 4 pattern sts 17 times

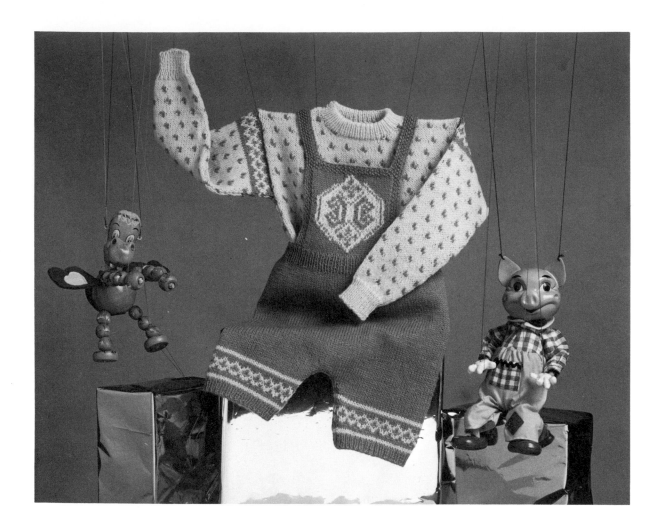

across, and working the last st on k rows and the first st on p rows as indicated.

Break off C and with MS, purl 1 row. Continue working in MS and st.st and increase 1 st at each end of the next 4 rows. 77 sts. Purl 1 row. **

Place the first leg on a spare needle.

Second leg
Work the second leg in the same manner, from * to **.

Join legs as follows: With right side facing, knit across second leg to the last st. Then with right side facing, pick up and knit together the first st of the first leg and the last st of the second leg. Then knit across the remaining sts of the first leg. 153 sts.

Continue straight until piece measures 20cm [8ins] from crotch, with right side facing for next row.

Decrease for waist as follows:
k1 * k2 tog, k3; rep from * to last 2 sts, k2 tog. 122 sts.

Purl 1 row.
Change to $2\frac{3}{4}$mm needles and work in k1, p1 rib for 6 rows.

Make buttonholes Rib 12, yo, k2 tog, rib to the last 14 sts, k2 tog, yo, rib 12. Rib for 2 more rows.

With wrong side facing, cast off the first 40 sts, rib to end of row.

Bib
Cast off the first 41 sts. Then change to

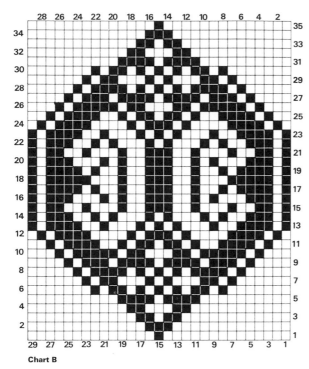

Chart B

Key
As Chart A

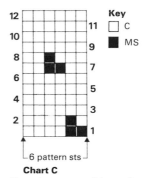

Chart C

3¼mm needles and work the remaining 41 sts of bib as follows:

Row 1: (k1, p1) twice, knit to the last 4 sts (k1, p1) twice.

Row 2: (p1, k1) twice, purl to the last 4 sts (p1, k1) twice.

Repeating these 2 rows, join in C and work the 35 rows of pattern from Chart B. Centre the motif by working st No.15 of chart into centre st (No.21) of bib.

Break off C, and work the next row (wrong side) as follows:

(p1, k1) twice, p16, p2 tog, p16, k1, p1, k1.
Now work top border as follows:

Row 1: * k1, p1; rep from * to end of row.
Row 2: * p1, k1; rep from * to end of row.
Work these 2 rows once more.

Next row: Pattern the first 6 sts and place on a safety pin. Cast off the next 28 sts. Pattern the remaining 6 sts.

Make straps Continue working these 6 sts until strap measures 33cm [13ins]. Cast off. Pick up the 6 sts from safety pin and work in the same manner.

Finishing
Omitting ribbing, press the piece using a warm iron and damp cloth.

Sew up centre back seam and press. Sew up leg/crotch seam and press. Sew 1 button 2cm [¾in] from end of each strap.

SWEATER

Back
* With 2¾mm needles and C, cast on 68 sts. k1, p1 rib for 4cm [1½ins].

Next row: Rib 2 (m1, rib 7) 9 times, m1, rib 3. 78 sts.

Change to 3¼mm needles and joining in MS, work the 12 rows of pattern from Chart C, repeating the 6 pattern sts 13 times across. **

Continue in this manner until back measures 33cm [13ins], with right side facing for next row.

Shape shoulders Keeping continuity of pattern, cast off 5 sts at beg of next 2 rows. Then cast off 6 sts at beg of next 6 rows. Leave the remaining 32 sts on a spare needle.

Front
As back from * to **.

Continue in this manner until front measures 30cm [11¾ins], with right side facing for next row.

Shape neck Pattern the first 28 sts. Leave the remaining sts on a spare needle.

Keeping continuity of pattern, turn and work these 28 sts, decreasing 1 st at beg (neck edge) of next and every foll. alt. row until 23 sts remain.

Shape left shoulder With right side facing, cast off 5 sts at beg of next row. Work 1 row. Then cast off 6 sts at beg of next and foll. alt. row, twice.

Front neck/right shoulder With right side facing, place the next (centre) 22 sts onto a length of yarn. Pick up the remaining 28 sts of right shoulder and work as left, reversing all shapings.

Sleeves
With 2¾mm needles and C, cast on 34 sts. k1, p1 rib for 3cm [1¼ins].

Next row: Rib 3 (m1, rib 4) 7 times, m1, rib 3. 42 sts.

Change to 3¼mm needles and joining in MS, work the pattern from Chart C, repeating the 6 pattern sts 7 times across. Increase 1 st at each end of the 3rd and every following 5th row, working increased sts into pattern, until there are 60 sts.

Continue straight until sleeve measures 19cm [7½ins] from beg.

Now work rows 3 to 13 of Chart A, increasing 1 st at beg of row 3 (61 sts). Repeat the 4 pattern sts 15 times across and work the last st on k rows, and the first st on p rows as indicated.

Break off C and with wrong side facing and MS, cast off.

Finishing
Omitting ribbing, press all pieces using a warm iron and damp cloth. Join back and front at left shoulder seam, and press.

Neckband With right side of work facing, 2¾mm needles and C, pick up and knit the 32 sts from back of neck, knit up 14 sts down left neck edge, pick up and knit the 22 sts of front neck, knit up 14 sts up right side of neck. 82 sts.

k1, p1 rib for 5cm [2ins]. Cast off loosely and evenly.

Turn neckband to inside and catchstitch neatly in position.

Join back and front at right shoulder seam, leaving a 5cm [2ins] opening at neck edge.

Buttonhole band With right side of work facing, 2¾mm needles and C, and starting at top of neckband, knit up 16 sts along front edge of neck opening. k1, p1 rib for 2 rows.

Next row: Rib 2, k2 tog, yo, rib 8, yo, k2 tog, rib 2.

Rib 3 more rows. Cast off.

Pin end of buttonhole band to back and catchstitch neatly in position. Sew buttons to back edge of opening, to correspond with buttonholes.

Attach sleeves to body, placing centre of sleeves at shoulder seams. Press seams. Sew up side and sleeve seams and press.

Trøndelag
Man's jacket

Trøndelag is the name given to the region surrounding Trondheim, and two items from this area particularly caught my attention. The first was a glove with a geometric diamond mesh overlaying vertical stripes of light and dark. I have used the pattern in this man's blouson jacket with dropped shoulders, knitted in chunky yarn. It is made in natural colours that are much softer than the original glove, which is a very dark brown and cream.

Materials
12 (13, 14, 15, 16) 50g balls of Chunky yarn in MS.

7 (8, 9, 10, 11) 50g balls of Chunky yarn in C.
1 pair each 5mm and 6½mm needles.
8 buttons.

The yarn used in this garment is Sirdar 'Pullman' Chunky Knit in Driftwood, with Caramel.

Measurements
To fit chest: 86 (91, 97, 102, 107)cm [34, (36, 38, 40, 42)ins]
Length from top of shoulder: 65, (66, 68, 70, 71)cm [25½ (26, 26¾, 27½, 28)ins]
Sleeve seam: 43, (46, 48, 49, 49)cm [17 (18, 19, 19½, 19½)ins]

Tension
16 sts and 16 rows to 10cm [4ins] measured over pattern using 6½mm needles.

Back
With 5mm needles and MS, cast on 62 (66, 70, 74, 78) sts.

k1, p1 rib for 8cm [3ins].

Next row: Rib 1 (3, 5, 7, 1) [m1, rib 4 (4, 4, 4, 5)] 15 times, m1, rib 1 (3, 5, 7, 2). 78 (82, 86, 90, 94) sts.

Change to 6½mm needles and joining in C, work the 14 rows of pattern from Chart, repeating the 12 pattern sts 6 (6, 7, 7, 7) times across, and working the first and last 3/5/1/3/5 sts on every row as indicated.

Continue in this manner until back measures 65 (66, 68, 70, 71)cm [25½ (26, 26¾, 27½, 28)ins], with right side facing for next row.

Shape shoulders Cast off 8 (8, 8, 9, 9) sts at beg of next 4 rows. Cast off 7 (8, 9, 8, 9) sts at beg of next 2 rows. Cast off the remaining 32 (34, 36, 38, 40) sts.

Right front
With 5mm needles and MS, cast on 30 (32, 34, 38, 38) sts.

k1, p1 rib for 8cm [3ins].

Next row: Rib 1 (2, 3, 1, 1) [m1, rib 4 (4, 4, 7, 5)] 7 (7, 7, 5, 7) times, m1, rib 1 (2, 3, 2, 2). 38 (40, 42, 44, 46) sts.

Change to 6½mm needles and joining in C, work the 14 rows of pattern from Chart, repeating the 12 pattern sts 3 times across, and working the first and last 1/2/3/4/5 sts on every row as indicated. Continue in this

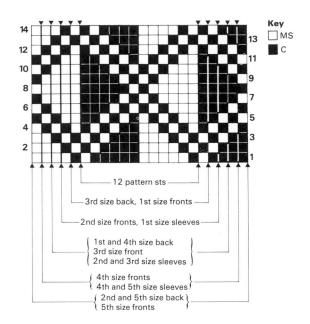

Key
☐ MS
■ C

12 pattern sts
3rd size back, 1st size fronts
2nd size fronts, 1st size sleeves
1st and 4th size back
3rd size front
2nd and 3rd size sleeves
4th size fronts
4th and 5th size sleeves
2nd and 5th size back
5th size fronts

manner until front measures 15cm [6ins] from beg, with right side facing for next row.

Make pocket openings Pattern 19 (20, 21, 22, 23) sts. Leave remaining sts on a spare needle. Turn, and work these sts for a further 17cm [6¾ins], with wrong side facing for next row. Now leave these sts on a spare needle and break off yarns. Rejoin yarns to the remaining 19 (20, 21, 22, 23) sts and work as first piece, ending on the *same pattern row*.

Next row: With wrong side facing, pattern 19 (20, 21, 22, 23) sts, pick up and pattern the 19 (20, 21, 22, 23) sts from spare needle, thus rejoining both pieces.

Pattern straight until front measures 57 (58, 60, 62, 63)cm [22½ (23, 23¾, 24½, 25)ins], with wrong side facing for next row.

Shape neck Pattern 31 (33, 34, 36, 39) sts. Slip the remaining 7 (7, 8, 8, 9) sts onto a length of yarn. Turn, and keeping continuity of pattern, decrease 1 st at neck edge of every row until 23 (24, 25, 26, 27) sts remain. Continue until front corresponds in length to back at shoulder, with wrong side facing for next row.

Shape shoulder Cast off 8 (8, 8, 9, 9) sts at shoulder edge of next 2 rows. Work 1 row.

Then cast off the remaining 7 (8, 9, 8, 9) sts.

Left front
As right but reversing all shapings.

Sleeves
With 5mm needles and MS, cast on 32 (34, 34, 36, 36) sts. k1, p1 rib for 8cm [3ins].
 Next row: Rib 2 (3, 3, 1, 1) [m1, rib 4 (4, 4, 5, 5)] 7 times, m1, rib 2 (3, 3, 0, 0). 40 (42, 42, 44, 44) sts.

Change to 6½mm needles and joining in C, work the 14 rows of pattern from Chart, repeating the 12 pattern sts 3 times across, and working the first and last 2/3/3/4/4 sts on every row as indicated. Continue in this manner, then increase 1 st at each end of the 3rd (2nd, next, 7th, 7th) pattern row, then on every foll. 4th (4th, 4th, 3rd, 3rd) row, until there are 64 (68, 72, 76, 80) sts (working increased sts into pattern). Continue straight until sleeve measures 43 (46, 48, 49, 49)cm [17 (18, 19, 19½, 19½)ins], with right side facing for next row. Cast off evenly.

Finishing
Omitting ribbing, press all pieces using a warm iron and damp cloth.

Right front pocket border With right side of work facing, 5mm needles and MS, and starting at top end of opening, knit up 27 sts along right side of pocket opening. k1, p1 rib – rows on wrong side having a p1 at each end. Rib for 6 rows. Cast off evenly in rib. Catch down ends of border to front.

Left front pocket border Work as right, but starting at the bottom end of opening. Knit up the 27 sts along left side of pocket opening.

Right front pocket lining With wrong side of work facing, 5mm needles and MS, starting at bottom end of opening, knit up 25 sts along left side of opening. Purl 1 row. Then working in st.st, increase 1 st at bottom edge of every row, until there are 35 sts. Work 6 rows straight. Then decrease 1 st

at each end of every row until 27 sts remain. Cast off.

Left front pocket lining As right, but begin at top end of right side of opening.

Press pocket linings and catch down to fronts. Sew fronts to back at shoulders. Press seams.

Neck With right side of work facing, 5mm needles and MS, starting at top of right front, knit the 7 (7, 8, 8, 9) sts of right front from length of yarn, decreasing 2 sts evenly, knit up 16 sts up right neck edge, knit up 31 (33, 33, 35, 37) sts from back neck, knit up 16 sts down left neck edge, then knit the 7 (7, 8, 8, 9) sts of left front from length of yarn, decreasing 2 sts evenly. 73 (75, 77, 79, 83) sts. k1, p1 rib – rows on wrong side having a p1 at each end – until neck measures 10cm [4ins]. Cast off evenly in rib. Fold neck in half to inside, and slip hem neatly in position.

Button border With 5mm needles and MS, cast on 8 sts.
 k1, p1 rib until band, when slightly stretched, fits up right front to top of neck border. Sew in position as you go along. Cast off evenly in rib.
 Before working buttonhole border, mark the position of buttons on button border with pins, to ensure even spacing, then work buttonholes to correspond.

Buttonhole border As button border, with the addition of 8 buttonholes. First to come 2cm [¾in] above lower edge, and last to come 2cm [¾in] below top of neck border, remainder spaced evenly between.

To make a buttonhole (right side) Rib 3, cast off 2, rib to end and back, casting on 2 over those cast off.

Attach sleeves to body, placing centre of sleeve at shoulder seam. Press seams. Sew up side and sleeve seams. Press seams. Sew on buttons.

Trøndelag
Man's sweater

The second item from Trøndelag that caught my imagination was a sock with an unusual tree-like pattern in black on a rust background. I used soft green and black for this Trøndelag sweater, and echoed the rare but distinctive tree pattern in a knit and purl stitch on the yoke. This sweater also has dropped shoulders and a reverse stocking stitch neckband.

Materials
9 (9, 10, 10, 11) 50g balls of Standard DK yarn in MS.
3 (3, 4, 4, 4) 50g balls of Standard DK yarn in C.
1 pair each 3¼mm and 4mm needles.

The yarn used in this garment is Hayfield 'Falkland' DK in Green with Black.

Measurements
To fit chest: 91 (97, 102, 107, 112)cm [36 (38, 40, 42, 44)ins]
Length from top of shoulder: 62 (63, 65, 66, 67)cm [24½ (25, 25½, 26, 26½)ins]

Tension
12 sts and 13 rows to 5cm [2ins] working in pattern and using 4mm needles.

Back
* With 3¼mm needles and MS cast on 102 (110, 116, 122, 130) sts.
 k1, p1 rib for 8cm [3ins].
 Next row: Rib 1 (3, 2, 1, 2) [m1, rib 10 (13, 14, 15, 21)] 10 (8, 8, 8, 6) times, m1, rib 1 (3, 2, 1, 2). 113 (119, 125, 131, 137) sts.
 Change to 4mm needles and joining in C work the pattern from Chart, repeating the

16 pattern sts 7 (7, 7, 8, 8) times across, and working the first 0/3/6/1/4 sts and last 1/4/7/2/5 sts on k rows, and the first 1/4/7/2/5 sts and last 0/3/6/1/4 sts on p rows as indicated. Work the first 6 pattern rows once, and thereafter work repeats of rows 7 to 22 as indicated. Continue in this manner until back measures 43cm [17ins] ending with right side facing for next row. Break off C yarn and working in MS only, k 2 rows, p 1 row, k 2 rows, p 1 row. Now work the pattern from Chart in k and p as indicated on Key, working the first 6 rows once only and thereafter work repeats of rows 7 to 22. **
 Continue in this manner until back measures 62 (63, 65, 66, 67)cm [24½ (25, 25½, 26, 26½)ins] from beg, ending with right side facing for next row.

Shape shoulder Cast off 12 (12, 13, 14, 14) sts at beg of next 2 rows. Cast off 12 (13, 13, 14, 15) sts at beg of next 2 rows. Then cast off 12 (13, 14, 14, 15) sts at beg of next 2 rows. Leave remaining 41 (43, 45, 47, 49) sts on a spare needle.

Front
As back from * to **. Continue working k/p yoke pattern until front measures 55 (57, 58,

59, 61)cm [22 (22½, 23, 23½, 24)ins] from beg, ending with right side facing for next row. Keeping continuity of pattern, work 46 (48, 50, 52, 54) sts. Place next 21 (23, 25, 27, 29) sts on a length of yarn (front neck). Place remaining sts on a spare needle. Turn and work the left shoulder, decreasing 1 st at neck edge of the next 6 rows. Work 1 row. Then decrease 1 st at neck edge of next and foll. alt. rows until 36 (38, 40, 52, 54) sts remain. Continue straight until shoulder corresponds in length to back, with right side of work facing for next row.

Shape shoulder Cast off 12 (12, 13, 14,14) sts at beg of next row. Work 1 row. Cast off 12 (13, 13, 14, 15) sts at beg of next row. Work 1 row. Cast off remaining 12 (13, 14, 14, 15) sts.

Pick up sts of right shoulder from spare needle and work as left shoulder, reversing all shapings.

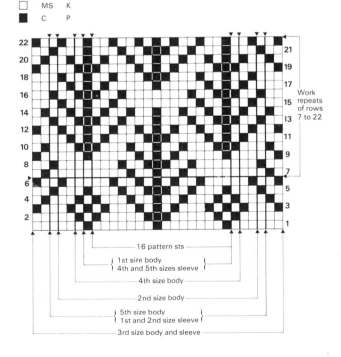

Key Body Yoke
☐ MS K
■ C P

16 pattern sts
1st size body
4th and 5th sizes sleeve
4th size body
2nd size body
5th size body
1st and 2nd size sleeve
3rd size body and sleeve

Work repeats of rows 7 to 22

Sleeves

With 3¼mm needles and MS cast on 50 (55, 56, 58, 58) sts.

k1, p1 rib for 8cm [3ins].

Next row: Rib 1 (1, 0, 2, 2) [m1, rib 8 (53, 14, 9, 9)] 6 (1, 4, 6, 6) times, m1, rib 1 (1, 0, 2, 2). 57 (57, 61, 65, 65) sts.

Change to 4mm needles and joining in C work pattern from Chart, repeating the 16 pattern sts 3 (3, 3, 4, 4) times across, and working the first 4/4/6/0/0 sts and the last 5/5/7/1/1 sts on k rows, and the first 5/5/7/1/1 sts and the last 4/4/6/0/0 sts on p rows as indicated. Work the first 6 rows once only and thereafter work repeats of rows 7 to 22 as indicated. Continue in this manner, increasing 1 st at each end of row 5 of pattern, and every following 5th (5th, 5th, 5th, 4th) row (working pattern into increased sts) until there are 91 (95, 99, 103, 107) sts. Continue straight until sleeve measures 46 (46, 47, 47, 49)cm [18½ (18½, 19, 19, 19½)ins] ending with right side facing for next row. Break off C, and with MS only, k 2 rows, p 1 row, k 1 row. Cast off evenly.

Finishing

Join back and front at left shoulder. With 3¼mm needles, and right side facing, pick up and knit 41 (43, 45, 47, 49) sts from back neck, 15 (15, 16, 16, 16) sts along left front, 21 (23, 25, 27, 29) sts from front neck, 15 (15, 16, 16, 16) sts along right front.

Next row: Knit.

Next row: Purl.

Repeat these 2 rows 10 (10, 10, 12, 12) more times. Cast off evenly. Fold neckband in half to the inside and catch down. Sew up right shoulder. Press seams. Attach sleeves, placing centre of sleeve at shoulder seams. Press. Sew up side and sleeve seams and press.

Dale
Woman's short-sleeved sweater

This short-sleeved sweater was inspired by another unusual pattern, on the wristband of a glove from Dale, Sunnfjord. The original is very bold, in black on a red ground. I have softened the over-all effect and added another colour to make it more feminine, using dusky pink and blue on a beige background. The body and collar are knitted in a simple lace stitch.

Materials
5 (6, 6, 6, 7) 50g balls of Standard 4-Ply yarn in MS.
1 50g ball of Standard 4-Ply yarn in 1st C.
1 50g ball of Standard 4-Ply yarn in 2nd C.
1 pair each $2\frac{3}{4}$mm and $3\frac{1}{4}$mm needles. 3mm crochet hook.
4 buttons.

The yarn used in this garment is Sirdar 'Majestic' 4-Ply in Driftwood with Evening Glow and Tender Blue.

Measurements
To fit bust: 81, (86, 91, 97, 102)cm [32, (34, 36, 38, 40)ins]
Length from top of shoulder: 57 (58, 60, 60, 61)cm [$22\frac{1}{2}$ (23, $23\frac{1}{2}$, $23\frac{1}{2}$, 24)ins]
Sleeve seam: 16cm [$6\frac{1}{4}$ins] all sizes.

Tension
14 sts and 17 rows to 5cm [2ins] measured over st.st and using $3\frac{1}{4}$mm needles.

Back
** With $2\frac{3}{4}$mm needles and MS, cast on 104 (112, 120, 128, 136) sts.
k1, p1 rib for 6cm [$2\frac{1}{2}$ins].
Next row: Rib 2 (1, 5, 3, 2) [m1, rib 9 (10, 10, 11, 12)] 11 times, m1, rib 3 (1, 5, 4, 2). 116 (124, 132, 140, 148) sts.

Change to $3\frac{1}{4}$mm needles and work pattern as follows: * k1, yo, p2 tog, k1; rep from *.
Repeat this row and continue until back measures 39cm [$15\frac{1}{2}$ins].

Shape armholes Keeping continuity of pattern, cast off 3 sts at beg of next 2 rows. Decrease 1 st at each end of the next 5 (5, 7, 7, 7) rows. Work 1 row. Then decrease 1 st at each end of every foll. alt. row until 92 (98, 104, 110, 118) sts remain.
Next row: p45 (48, 51, 54, 58), p2 tog, p45 (48, 51, 54, 58). 91 (97, 103, 109, 117) sts.
Then joining in and breaking off colours as required, work the 14 rows of pattern from Chart, repeating the 18 pattern sts 5 (5, 5, 6, 6) times across, and working the first 0/3/6/0/4/ sts and the last 1/4/7/1/5 sts on k rows, and the first 1/4/7/1/5 sts and the last 0/3/6/0/4 sts on p rows as indicated.**
Continue in this manner until back measures 57 (58, 60, 60, 61)cm [$22\frac{1}{2}$ (23, $23\frac{1}{2}$, $23\frac{1}{2}$, 24)ins] from beg, with right side facing for next row.

Shape shoulders Keeping continuity of pattern, cast off 13 (14, 15, 16, 17) sts at beg of next 4 rows. Leave remaining 39 (41, 43, 45, 47) sts on a spare needle.

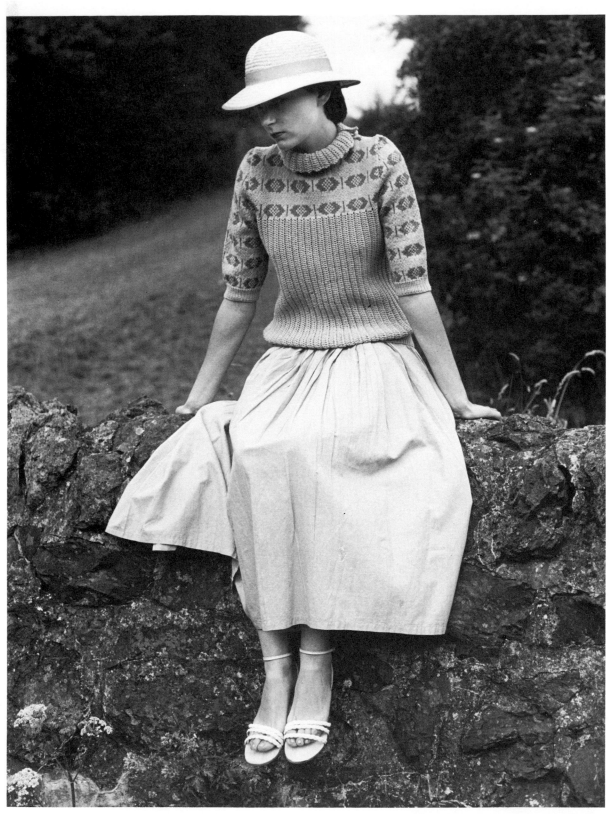

OPPOSITE ABOVE: Nomad (page 41).
OPPOSITE BELOW: Astrakan (page 120).

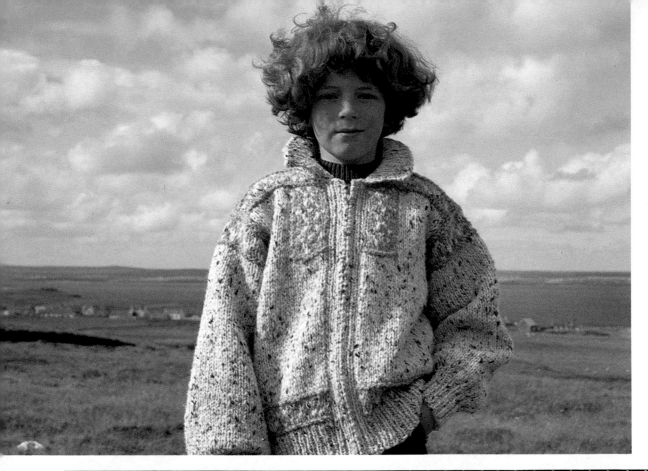

Finishing

Omitting ribbing and lace pattern, press all pieces using a warm iron and damp cloth. Join back and front at right shoulder seam. Press.

Collar With 2¾mm needles, MS, right side of work facing, and beginning at top left front of neck, knit up 12 sts down left side of neck, knit the 23 (25, 27, 29, 31) sts from front neck, knit up 12 sts up right side of neck, knit the 39 (41, 43, 45, 47) sts across back neck. 86 (90, 94, 98, 102) sts.

k1, p1 rib for 2cm [¾in].

Next row: Rib 1 (3, 5, 7, 9), (m1, rib 4) 21 times, m1, rib 1 (3, 5, 7, 9). 108 (112, 116, 120, 124) sts.

Change to 3¼mm needles and work in lace pattern as back, for 5cm [2ins].

Cast off loosely and evenly.

Beginning at shoulder edge, join left shoulder seam for 5cm [2ins]. Press seam.

Neck opening With 3mm crochet hook, MS, right side of work facing, and beginning at back edge of collar, work 3 rounds of DC around neck opening, making 3 buttonholes on front side of opening of final round. Place the first buttonhole at shoulder edge of opening, and last buttonhole at top of neck rib.

Sew up side and sleeve seams. Insert sleeves. Press seams gently.

Lapland
Midnight Sun

It was perhaps to be expected that my travels on the sparsely populated Arctic section of my journey would yield the least actual knitted material. In terms of inspiration, however, it proved spectacular.

Coming as I do from an island in one of the most remote parts of Scotland, I thought I would be quite prepared for the impact of the Arctic wilderness. However, on arrival in this magical, awe-inspiring part of the world, I felt more like a visitor from a sedate English shire.

Politically, Lapland does not exist. It stretches across the far north of Europe and spans four countries, from the Kola Peninsula in the Soviet Union, across northern Finland and Sweden to the coast of Norway. This vast area includes such varied terrain as mountain, forest and tundra, and the lifestyle of its people has for centuries been based around the herding of just one species of animal – the reindeer. The Lapps are a unique race, totally different from the rest of the Scandinavians. They are physically short and sturdy, wearing bright costumes, and it is only too easy for the visitor to romanticise about their colourful way of life. However, the truth is far from romantic. The fact that they have survived and flourished is a testimony to their phenomenal powers of adaptation to powerful neighbours and a harsh environment. Most of Lapland is covered in snow for about two-thirds of the year, and, as if violent gales, blizzards, low cloud and drastic temperature changes were not enough, the sun disappears in winter for up to seventy days. In summer, of course, it never sets – for over twelve weeks in the northern latitudes.

Modern technology has aided the Lapps in their fight against the climate, and the present-day Lapp homestead is just as likely to have a Sno-Cat parked outside as a reindeer sled. But there is another side to this coin. Under the pressure of influences such as mining, hydro-electricity and tourism, the traditional way of life has almost disappeared. Lapland is shrinking fast.

Part of the Lapps' successful adaptation to their environment has been due to their skillful use of natural raw materials, and their handicraft tradition is old and comprehensive. Reindeer products, both horn and hide, figure largely, as does woodcarving. Clothes are made from hide and woven material, richly embroidered and decorated with tassles and bright, multi-coloured woven bands – a particular Lapp speciality. This love of bright colours manifests itself in many ways. Reindeer harnesses, for example, are decorated with tassles and coloured felt.

Knitting forms only a small part of the Lapps' general craft tradition. Most of it is plain, the only colourwork being found on mittens or gloves, and even then it is confined to the wrist border and the back of the hand. Diamond patterns are favoured, although border patterns are more varied and show a similarity to Norwegian knitting in their simple, geometric nature. However, the use of colour could not be more different. The Lapps prefer bright, almost brash colours, and, unlike the Norwegians, often use several together in one design.

Midnight sun
Child's dress and hat

The Lapps have different costumes for summer and winter, and these are worn by men, women and children alike. The winter outfit is made from hide but the summer costume consists of a tunic in black or royal blue cloth, adorned with distinctive woven bands in bright red and gold. The hats which accompany the tunics are also brightly decorated with bands and tassles.

We have seen how knitters of the last two centuries took their ideas from woven originals and I have followed this tradition by basing a girl's dress on the Lapp summer costume, using not only the original colours – royal blue, red and gold – but also the shape of the woven garment. The hat too is a faithful knitted version, with earflaps and tassle decorations.

This particular pattern will be of interest to the adventurous knitter, as there is always something to do. The skirt is precisely shaped and there are different borders to be worked, including a vertical panel.

(See colour photograph on front of jacket.)

Materials
15 25g balls of Standard DK yarn in MS.
2 25g balls of Standard DK yarn in 1st C.
2 25g balls of Standard DK yarn in 2nd C.
1 pair 4½mm needles.

Measurements
Age 6 to 7 years
To fit chest: 66cm [26ins]
Length from top of shoulder: 63cm [24¾ins]
Sleeve seam: 33cm [13ins]

Tension
11 sts and 14 rows to 5cm [2ins] measured over st.st using 4½mm needles.

DRESS

Back
** With 4½mm needles and MS, cast on 133 sts.

Knit 6 rows in garter st. Pattern skirt as follows:

Row 1: * p1, k32; rep from * to the last st, p1.

Row 2: * k1, p32; rep from * to the last st, k1.

Repeat these 2 rows 5 more times.

With right side facing, work the first decrease as follows:

* p1, ssk, k28, k2 tog; rep from * to last st, p1.

Continue straight for 11 rows, i.e. k all k sts, and p all p sts.

Then decrease as previously, i.e. at each side of purl sts, thus decreasing by 8 sts.

Continue in this manner, working 11 rows straight, then decreasing on every 12th row, until 7 decrease rows have been worked and 77 sts remain. Then continue straight until skirt measures 39cm [15½ins], with right side facing for next row. **

Join in contrast yarns and work the 15

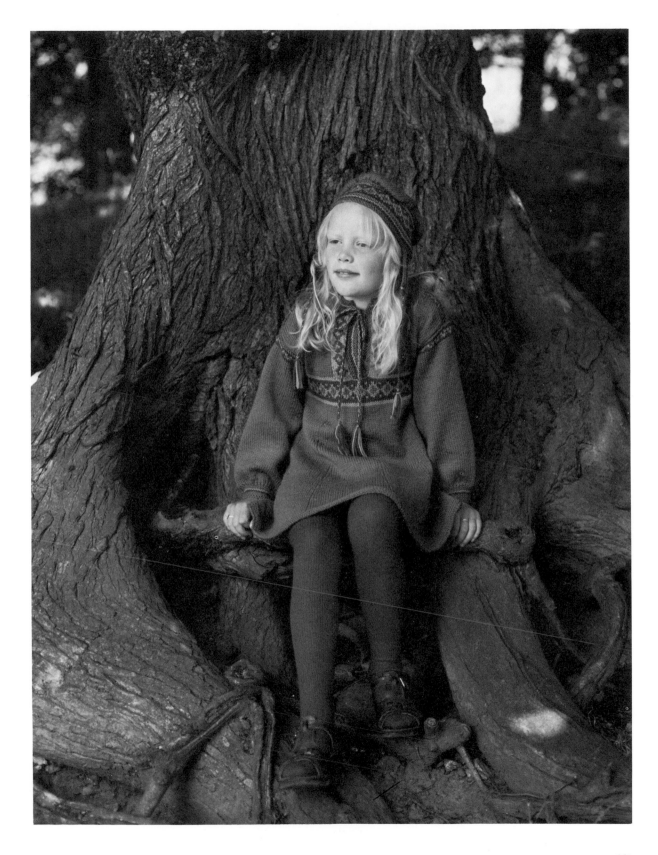

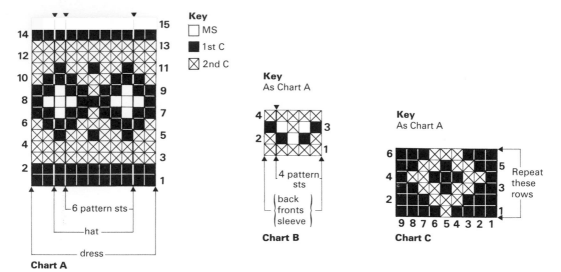

Key
☐ MS
■ 1st C
⊠ 2nd C

Key
As Chart A

Key
As Chart A

4 pattern sts
{ back fronts sleeve }

Chart A

Chart B

Chart C
Repeat these rows

rows of pattern from Chart A, repeating the 6 pattern sts 12 times across, and working the first 2 sts and the last 3 sts on k rows, and the first 3 sts and the last 2 sts on p rows as indicated.

Break off contrast yarns and continue straight in MS and st.st, until back measures 61cm [24ins] from beg, with right side facing for next row.

Join in contrast yarns and work the 4 rows of pattern from Chart B, repeating the 4 pattern sts 19 times across, and working the last st on k rows and the first st on p rows as indicated.

Break off contrast yarns, and with MS, knit 1 row.

Then with wrong side facing, cast off knitwise.

Front
As back from ** to **.

Join in contrast yarns and work the pattern from Chart A as back, but working the first *14 rows only*. Break off MS and 2nd C.

Divide for front opening With right side facing and 1st C, knit 36 sts. Leave the remaining 41 sts on a spare needle. Turn, and work the 36 sts of left side as follows:

With 1st C, purl 9 sts, join in MS, and purl to end of row.

Next row: Knit 27 sts in MS, then joining in 2nd C, work the 9 sts of pattern from Chart C, into the remaining 9 sts.

Continue in this manner, repeating the 6 pattern rows as indicated.

(NB: Cross MS and 1st C on wrong side in order to avoid gaps between Chart C and main piece. See paragraph on vertical panels on page 125.)

Work 5 repeats of Chart C (30 rows), then work rows 1 to 3 once more.

Shape neck With wrong side facing, and keeping continuity of pattern, cast off 4 sts at beg of next row. Then decrease 1 st at neck edge of next and every foll. row until 29 sts remain. Work 1 row straight.

Break off contrast yarns.

With right side facing, rejoin contrast yarns and work the 4 rows of pattern from Chart B, repeating the 4 pattern sts 7 times across, and working the last st on k rows and the first st on p rows as indicated.

Break off contrast yarns, and with MS, knit 1 row.

Then with wrong side facing, cast off knitwise.

Right side With right side of work facing, and 1st C, pick up and cast off the first 5 sts from spare needle (centre opening).

Work the remaining 36 sts of right side as left, reversing Chart C position and all shapings. Work rows 1 to 4 after last repeat of Chart C, before shaping neck.

Sleeves

With 4½mm needles and MS, cast on 32 sts.
Knit colour sequence in garter st as follows:

6 rows MS/2 rows 2nd C/2 rows 1st C/6 rows MS.

Break off contrast yarns, and with MS, increase as follows:

k1, k twice into every st to end of row. 63 sts.

Work straight in st.st for 10 rows. Then increase 1 st at each end of next and every foll. 10th row until there are 73 sts.

Continue straight until sleeve measures 31cm [12¼ins], with right side facing for next row.

Join in contrast yarns and work the 4 rows of pattern from Chart B, repeating the 4 pattern sts 18 times across, and working the last st on k rows, and the first st on p rows as indicated.

Break off contrast yarns, and with MS, knit 1 row.

Then with wrong side facing, cast off knitwise.

Finishing

Press all pieces using a warm iron and damp cloth. Join back and front at shoulder seams. Press seams.

Left side opening With right side of work facing, MS, and starting at top end of opening, knit up 24 sts along left opening. Knit colour sequence in garter st as follows:

3 rows MS/2 rows 2nd C/2 rows 1st C/2 rows MS.

Break off contrast yarns and cast off evenly in MS.

Right side opening As left but starting at the bottom end of opening.

Stitch end of left opening to centre cast off sts. Then stitch end of right opening over left. Press gently.

Neckband With right side of work facing, MS, and starting at 2nd C stripe of right opening, knit up 16 sts evenly along to shoulder seam, knit up 24 sts evenly along back of neck, then knit up 16 sts evenly along to 2nd C stripe of left opening. 56 sts.

Knit colour sequence in garter st as follows:

3 rows MS/2 rows 2nd C/2 rows 1st C/3 rows MS.

Break off contrast yarns and cast off evenly in MS.

Attach sleeves to body, placing centre of sleeve at shoulder seam. Press seams. Sew up side and sleeve seams and press.

HAT

Band

With 4½mm needles and MS, cast on 103 sts.

Knit colour sequence in garter st as follows:

2 rows MS/2 rows 2nd C/2 rows 1st C/2 rows MS.

Now work the 15 rows of pattern from Chart A, repeating the 6 pattern sts 17 times across, and working the last st on k rows, and the first st on p rows as indicated.

Break off contrast yarns and with MS, knit 1 row.

Then with wrong side facing cast off knitwise, marking the 52nd st with a small piece of yarn.

Top

With MS, cast on 19 sts, and mark the 10th st with a small piece of yarn. Work in st.st and increase 1 st at each end of the first and every foll. alt. row until there are 45 sts. Work 13 rows straight. Then decrease 1 st at each end of next and every foll. alt. row until 19 sts remain. Cast off, marking the 10th st as before.

Earflaps

With MS, cast on 16 sts.

Knit colour sequence in garter st as follows:

2 rows MS/2 rows 2nd C/2 rows 1st C.

Repeat this sequence 2 more times.

Break off contrast yarns and knit 2 rows in MS. Cast off evenly.

Finishing

Press all pieces using a warm iron and damp cloth.

Join ends of band to form a circle, and press seam.

Attach top to band by pinning 1 marked st of top to the marked st of band (centre front). Then pin the other marked st of top to band at seam (centre back). Then pin top to band all around edge, gathering lightly. Stitch firmly in position.

Pin one end of earflaps (so that stripes hang vertically) to bottom edge of band, 8cm [3ins] on each side of centre back seam. Press seams.

Make ties Using equal amounts of 1st and 2nd C, cut 2 sets of 6 strands 51cm [20ins] long, and 2 sets of 6 strands 33cm [13ins] long. Plait each set and knot 8cm [3ins] from end to form a tassle.

Attach the longer ties to dress, one on each side of front opening, stitching firmly on the wrong side of openings.

Attach the shorter ties to the centre bottom edge of earflaps, and stitch firmly to wrong side.

Nomad
Child's blouson jacket

During the short Lapp summer, snow remains on the mountains while the lowlands take on a range of subtle, muted shades that blend perfectly together. Stand still, and individual detail emerges. Grey-browns for instance, could turn out to be reindeer moving slowly across the landscape. In this chunky blouson jacket, I have tried to capture this effect by using flecked grey yarn as a main shade and flecked lichen green as a contrast. The borderwork and vertical panels on the front are taken from the border of a Lapp glove in the museum at Tromsø in Norway.

(See colour photograph opposite page 32.)

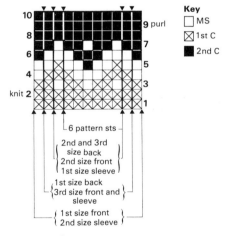

Chart A

Materials
8 (8, 9) 50g balls of Chunky yarn in MS.
1 50g ball of Chunky yarn in 1st C.
1 50g ball of Chunky yarn in 2nd C.
1 pair each 5mm and 6½mm needles.
30.5 (35.5, 40.5)cm [12, (14, 16)ins] open-ended zip fastener.

Measurements
Age 6 to 7 (8 to 9, 10 to 11) years
To fit chest: 66 (71, 76)cm [26 (28, 30)ins]
Length from top of shoulder: 42 (46, 50)cm [16½ (18, 20)ins]
Sleeve seam: 30 (34, 38)cm [12 (13½, 15)ins]

Tension
14 sts and 17 rows to 10cm [4ins] measured over st.st using 6½mm needles.

Back
With 5mm needles and MS, cast on 42 (46, 52) sts.

k1, p1 rib for 6 (6, 8)cm [2½ (2½, 3)ins].

Next row: Rib 1 (3, 2) [m1, rib 5 (5, 6)] 8 times, m1, rib 1 (3, 2). 51 (55, 61) sts.

Change to 6½mm needles and joining in contrast yarns, work the 10 rows of border

pattern from Chart A, knitting row 2 on wrong side and purling row 9 on right side, as indicated. Repeat the 6 pattern sts 8 (9, 10) times across, and work the first 1/0/0 sts and the last 2/1/1 sts on k rows, and the first 2/1/1 sts and the last 1/0/0 sts on p rows as indicated.

Break off contrast yarns, and with MS continue straight in st.st until back measures 27 (29, 33)cm [10½ (11¼, 13)ins] from beg, with right side facing for next row.

41

Shape armholes Cast off 6 sts at beg of next 2 rows. Then continue straight until armhole measures 10 (11, 12)cm [4 (4¼, 4¾)ins] with right side facing for next row. Join in contrast yarns and work the 10 rows of border pattern from Chart A, repeating the 6 pattern sts 6 (7, 8) times across, and working the edge sts as lower border. Break off MS, and 1st C, then with 2nd C and right side facing, cast off purlwise.

Left front
With 5mm needles and MS, cast on 20 (22, 24) sts.
k1, p1 rib for 6 (6, 8)cm [2½ (2½, 3)ins].
Next row: Rib 1 [m1, rib 9 (10, 11)] twice, m1, rib 1. 23 (25, 27) sts.
Change to 6½mm needles and joining in contrast yarns, work the 10 rows of border pattern from Chart A, repeating the 6 pattern sts 3 (4, 4) times across, and working the first 2/0/1 sts and the last 3/1/2 sts on k rows, and the first 3/1/2 sts and the last 2/0/1 sts on p rows as indicated.
Break off contrast yarns, and with MS, continue straight in st.st until front measures 27 (29, 33)cm [10½ (11¼, 13)ins] from beg, with right side facing for next row.

Shape armhole Cast off 6, k8 (10, 12). Then join in contrast yarns and work the 9 pattern sts from Chart B into the remaining 9 sts.
(NB: Cross MS and 2nd C on wrong side, in order to avoid gaps between chart pattern and main piece. See paragraph on vertical panels on page 125.)
Continue straight, working rows 1 to 8 of Chart B once. Then work repeats of rows 3 to 8 as indicated, until armhole measures 10 (11, 12)cm [4 (4¼, 4¾)ins], with right side facing for next row.
Break off contrast yarns, then rejoin and work rows 1 to 3 of pattern from Chart A, repeating the 6 pattern sts 2 (3, 3) times across, and working the edge sts as lower border.

Shape neck With wrong side facing and keeping continuity of pattern, cast off 3 (3,

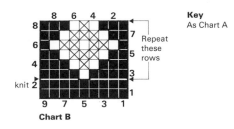

Chart B

Key
As Chart A

4) sts at beg of row. Then decrease 1 st at neck edge of the next 2 (3, 3) rows. Work 1 row. Then decrease 1 st at neck edge of the next row. Continue and complete the 10 rows of Chart A.
Break off MS and 1st C, and with 2nd C and right side facing, cast off purlwise.

Right front
As left, but reversing Chart B position and all shapings.
(NB: Begin working Chart B on the *same* right side row as left front. Then cast off for armhole on the next row. Work rows 1 to 4 of pattern from Chart A before shaping neck.)

Sleeves
With 5mm needles and MS, cast on 26 (28, 30) sts.
k1, p1 rib for 5cm [2ins].
Next row: Rib 5 (m1, rib 1) 16 (18, 20) times, m1, rib 5. 43 (47, 51) sts.
Change to 6½mm needles and work straight in st.st until sleeve measures 30 (34, 38cm [12 (13½, 15)ins], with right side facing for next row.
Join in contrast yarns and work the 10 rows of border pattern from Chart A, repeating the 6 pattern sts 7 (7, 8) times across, and working the first 0/2/1 sts and the last 1/3/2 sts on k rows, and the first 1/3/2 sts and the last 0/2/1 sts on p rows as indicated.
Break off MS and 1st C, and with 2nd C and right side facing, cast off purlwise.

Collar
With 5mm needles and MS, cast on 52 (56, 60) sts.
k1, p1 rib for 6 (8, 8)cm [2½ (3, 3)ins]. Cast off loosely and evenly in rib.

Finishing

Omitting ribbing, press all pieces using a warm iron and a damp cloth.

Front borders (2 alike) With 5mm needles and MS, cast on 6 sts.

k1, p1 rib until band, when slightly stretched, fits up front from bottom to top. Sew in position as you go along.

Join fronts to back at shoulders, and press seams.

Pin the cast on edge of collar to neck, positioning each end of collar at centre of front borders. Stitch neatly in position.

Attach sleeves to body, placing centre of sleeve at shoulder seam. Sew cast off sts of armholes to patterned edges of sleeves. Press seams. Sew side and sleeve seams and press. Insert zip.

Arctic
Child's two-piece suit

The winter landscape could not be more different from the summer one, and the main shade for this combination of tunic and trews is, quite naturally, white. The woven stitch panels at front and back add extra thickness and warmth, while the tassle on the hood is typically Lapp. Again the borders come from a Lapp glove, in soft wine and blue on a white background.

Materials
8 (9) 50g balls of Chunky yarn in MS.
1 (1) 50g ball of Chunky yarn in 1st C.
1 (1) 50g ball of Chunky yarn in 2nd C.
1 pair each 5mm and 6½mm needles. 5mm crochet hook.
2 buttons in MS.

Measurements
Age 1 to 2 (2 to 3) years
Top
To fit chest: 53 (56)cm [21 (22)ins]
Length from top of shoulder: 31 (36)cm [12¼ (14¼)ins]
Sleeve seam: 19 (23)cm [7½ (9)ins]
Trews
Inside leg seam: 28 (35)cm [11 (14)ins]

Tension
14 sts and 17 rows to 10cm [4ins] measured over st.st using 6½mm needles.

TOP

Back
** With 6½mm needles and MS, cast on 41 (45) sts.
 Knit 5 rows in garter st. Purl 1 row.
 Joining in and breaking off contrast yarns as required, work the 8 rows of border pattern, repeating the 6 pattern sts 6 (7) times across, and working the first 2/1 sts and the last 3/2 sts on k rows, and the first 3/2 sts and the last 2/1 sts on p rows as indicated.
 Break off contrast yarns, and with MS continue straight in st.st until back measures 19 (23)cm [7½ (9)ins] from beg, with wrong side facing for next row.
 Next row: p20 (22), p2 tog, p19 (21). 40 (44) sts.

Shape armholes Cast off 10 (12) sts at beg of next 2 rows. **
 Now work the 20 sts of back yoke as follows:

Row 1: (Right side) With 1st C, k1, * yf sl 2, k2; rep from * to the last 3 sts, yf sl 2, k1.
Row 2: With 2nd C, k1, p2, * yb sl 2, p2; rep from * to the last st, k1.
Row 3: With MS, repeat Row 1.
Row 4: With 1st C, repeat Row 2.
Row 5: With 2nd C, repeat Row 1.
Row 6: With MS, repeat Row 2.

Repeat rows 1 to 6 until yoke measures 12 (13)cm [4¾ (5¼)ins].
 Break off contrast yarns and cast off in MS.

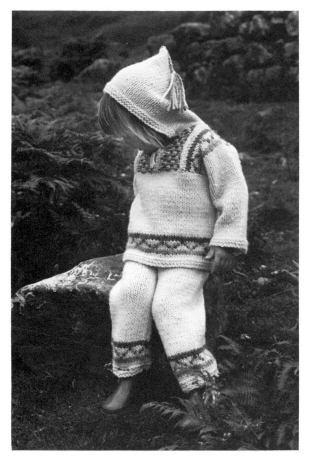

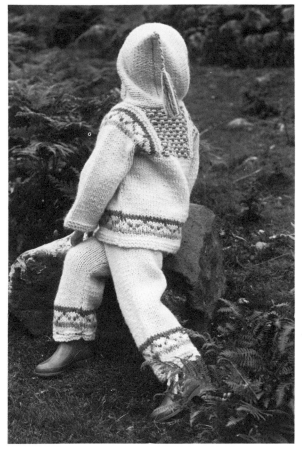

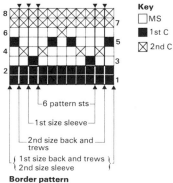

Key

□ MS

■ 1st C

⊠ 2nd C

6 pattern sts

1st size sleeve

2nd size back and trews

1st size back and trews
2nd size sleeve

Border pattern

Row 3: With MS, repeat Row 1.

Row 4: With 1st C, repeat Row 2.

Row 5: With 2nd C, repeat Row 1.

Row 6: With MS repeat Row 2.

Repeat rows 1 to 6 until yoke measures 8 (9)cm [3 (3½)ins], with wrong side facing for next row.

Shape neck Cast off 3 sts at beg of row. (Break off unworked yarns and rejoin after cast off.)

Keeping continuity of pattern as far as possible, decrease 1 st at neck edge of next 2 rows. Work 1 row. Then decrease 1 st at neck edge of next and foll. alt. row. Work 1 row.

Next row: sl 1, k2 tog, psso. Pass the yarn through the last st, to cast off.

Break off all yarns.

Front

As back from ** to **.

Divide for front opening, and work left yoke as follows:

Row 1: (Right side) With 1st C, k1 (yf sl 2, k2) twice, k1. (Leave the remaining 10 sts on a spare needle, and turn.)

Row 2: With 2nd C, k1 (yb sl 2, p2) twice, k1.

Right yoke With right side facing, pick up the 10 sts from spare needle, and work pattern as left yoke, but reversing all shapings.

Sleeves
With 6½mm needles and MS, cast on 31 (35) sts. Knit 4 rows in garter st.

Then continue straight in st.st until sleeve measures 22 (27)cm [8¾ (10½)ins], with right side facing for next row.

Joining in and breaking off contrast yarns as required, work the 8 rows of border pattern from Chart, repeating the 6 pattern sts 5 times across, and working the first 0/2 sts and the last 1/3 sts on k rows, and the first 1/3 sts and the last 0/2 sts on p rows as indicated.

Break off contrast yarns, and with MS knit 2 rows. Cast off evenly.

Hood
With 6½mm needles and MS, cast on 52 (58) sts.

Knit 4 rows in garter st. Continue straight in st.st until piece measures 20cm [8ins]. Cast off evenly.

Finishing
Press all pieces using a warm iron and damp cloth.

Lay out back, front and sleeves, wrong side up, as diagram. Then sew sleeves neatly in position. Press seams. Sew up side and sleeve seams and press. With wrong side out, fold hood in half and sew along seam formed by cast off edges. Press seam.

Attach hood, positioning seam at centre of back yoke. Sew neatly around neck.

Front openings With right side facing, 5mm crochet hook and MS, work 2 rows of DC along each side of opening.

Make ties Using MS, make 2 plaits, each 30cm [12ins] long. Knot 5cm [2ins] from end to form a tassle. Attach 1 tie to either side of opening and sew firmly on inside.

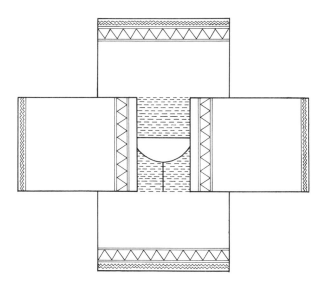

Layout for sleeve insertions

Hood plait and tassle Using 1 strand of each colour, make a plait 10cm [4ins] long. Then using several strands of each colour, make a thick tassle 10cm [4ins] long and attach to plait. Thread plait through top of hood seam, and fasten on inside.

TREWS

Leg
** With 6½mm needles and MS, cast on 41 (45) sts. Knit 2 rows.

Next row: k1 * k2 tog, yo, k2; rep from * to end of row.

Knit 2 rows.

Purl 1 row.

Joining in and breaking off contrast yarns as required, work the 8 rows of border pattern as back.

Break off contrast yarns and continue straight in MS and st.st, until leg measures 15 (22)cm [6 (8¾)ins], with right side facing for next row.

Shape leg as follows:

Increase 1 st at each end of next and every foll. 4th row, until there are 51 (55) sts.

Continue straight until leg measures 28 (35)cm [11 (14)ins], with right side facing for next row.

Shape crotch Cast off 2 sts at beg of next 2 rows. Then decrease 1 st at each end of next and every foll. alt. row until 41 (45) sts remain. Purl 1 row. **

Place these sts on a spare needle and work another leg as before, from ** to **.

Join legs as follows:

Knit across 2nd leg to last st. Then, with right side facing, pick up the sts of first leg from spare needle, and knit the first st of this leg and the last st of 2nd leg together. Then knit across the remaining sts of first leg. 81 (89) sts.

Continue straight until piece measures 19 (22)cm [7½ (8½)ins] from crotch, with right side facing for next row.

Change to 5mm needles and k1, p1 rib for 4cm [1½ins], (right side rows ending on a k st).

Next row: Cast off 8 sts, rib 6 and place these sts on a safety pin, cast off the next 53 (61) sts, rib 6 and place these sts on a safety pin, cast off the remaining sts.

Make straps With 5mm needles and MS, pick up the 6 sts from safety pin, and rib until straps measure 23 (26)cm [9 (10¼)ins].

Next row: Make buttonhole: Rib 2, yo, k2 tog, rib 2.

Rib 2 more rows, then cast off neatly.

Finishing

Press trews using a warm iron and a damp cloth.

Sew up front crotch seam and press.

Sew up centre back seam from crotch to waist, and press. Sew up inside leg seams and press.

Make ties Using 1 strand of each colour, make 2 plaits each 51cm [20ins] long.

Knot 3cm [1in] from one end to form a tassle. Thread the ties through the holes at ankles of each leg. Then knot the remaining ends of ties 3cm [1in] from ends to form a tassle.

Attach buttons to front rib, to correspond with straps.

Skåne
Man's or woman's sweater

Skåne has throughout history been the breadbasket of Sweden. In a country where less than 10 per cent of the land is under cultivation, the southernmost province of Skåne stands out as being rich and fertile. It is also the home of one of the most famous Swedish patterns – an unusual tile effect of complex thistle-like motifs which I saw on a nineteenth century sweater knitted in white on a blue ground. This pattern is nationally very popular and represents one of the last vestiges of professional knitting. Coats featuring this pattern can be purchased today, knitted on very fine needles and usually from three colours – white, red and blue.

I have stuck to the original colours of blue and white for this sweater in a loose, sporty style that can be worn by both sexes. It has a dropped shoulder, round neck with small front opening, and a narrow crochet trim. The photograph shows how the main shade and contrast can be successfully reversed.

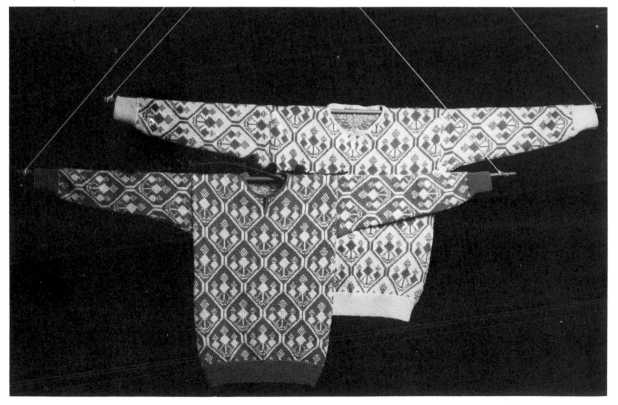

Key
□ MS
⊡ C

Materials

8 (8, 9, 9, 10) 50g balls of Standard DK yarn in MS.

4 (4, 5, 5, 5) 50g balls of Standard DK yarn in C.

1 pair each 3¼mm and 4mm needles. 4mm crochet hook.

The yarn used in this garment is Hayfield 'Falkland' DK in Blue with Cream.

Measurements

To fit chest/bust: 86 (91, 97, 102, 107)cm [34 (36, 38, 40, 42)ins]

Length from top of shoulder: 62 (63, 65, 66, 67)cm [24½ (25, 25½, 26, 26½)ins]

Sleeve seam: 44 (44, 46, 48, 49)cm [17½ (17½, 18, 19, 19½)ins]

Tension

12 sts and 13 rows to 5cm [2ins] working in pattern using 4mm needles.

Back

* With 3¼mm needles and MS, cast on 102 (110, 116, 122, 130) sts.

k1, p1 rib for 8cm [3ins].

Next row: Rib 1 (3, 2, 1, 2) [m1, rib 10 (13, 14, 15, 21)] 10 (8, 8, 8, 6) times, m1, rib 1 (3, 2, 1, 2). 113 (119, 125, 131, 137) sts.

Change to 4mm needles and joining in C, work the 38 rows of pattern from Chart, repeating the 32 pattern sts 3 (3, 3, 4, 4) times across, and working the first 8/11/14/1/4 sts and the last 9/12/15/2/5 sts on k rows, and the first 9/12/15/2/5 sts and the last 8/11/14/1/4 sts on p rows as indicated. ** Continue in this manner until back measures 62 (63, 65, 66, 67)cm [24½ (25, 25½, 26, 26½) ins] from beg, with right side facing for next row.

Shape shoulder Cast off 12 (13, 13, 14, 15) sts at beg of next 2 rows. Cast off 12 (13, 14,

14, 15) sts at beg of next 2 rows. Cast off 13 (13, 14, 15, 15) sts at beg of next 2 rows. Then cast off the remaining 39 (41, 43, 45, 47) sts.

Front

As back from * to **.

Continue in this manner until front measures 51 (52, 54, 55, 56)cm [20 (20½, 21, 21½, 22)ins], with right side facing for next row.

Next row: Pattern 56 (59, 62, 65, 68) sts. Place remaining sts on a spare needle. Turn, and continue working these sts for left side for another 5cm [2ins], ending with wrong side facing for next row.

Shape neck Cast off 6 (6, 7, 8, 9) sts at beg of next row. Then keeping continuity of pattern, decrease 1 st at neck edge of every row until 37 (39, 41, 43, 45) sts remain. Continue straight until front corresponds with back at shoulder, with right side facing for next row.

Shape shoulder Cast off 12 (13, 13, 14, 15) sts at beg of next row. Work 1 row. Cast off 12 (13, 14, 14, 15) sts at beg of next row. Work 1 row. Then cast off remaining 13 (13, 14, 15, 15) sts.

With right side of work facing, pick up sts from spare needle and cast off the first (centre front) st. Work the remaining sts of right side as left side, but reversing all shapings.

Sleeves

With 3¼mm needles and MS, cast on 50 (52, 52, 59, 59) sts.

k1, p1 rib for 8cm [3ins].

Next row: Rib 1 (2, 2, 1, 1) [m1, rib 12 (6, 6, 11, 11)] 4 (8, 8, 5, 5) times, m1, rib 1 (2, 2, 3, 3). 55 (61, 61, 65, 65) sts.

Change to 4mm needles and joining in C, work the 38 rows of pattern, working the 32 pattern sts 1 (1, 1, 2, 2) times across, and working the first 11/14/14/0/0 sts and the last 12/15/15/1/1 sts on k rows, and the first 12/15/15/1/1 sts and the last 11/14/14/0/0 sts on p rows as indicated.

Increase 1 st at each end of every 4th (4th, 4th, 5th, 4th) row until there are 91 (97, 101, 105, 111) sts (working pattern into increased sts). Continue straight until sleeve measures 44 (44, 46, 48, 49)cm [17½ (17½, 18, 19, 19½)ins]. Cast off evenly.

Finishing

Omitting ribbing, press all pieces using a warm iron and damp cloth. Join back and front at shoulders. Press seams.

Neck

With 4mm crochet hook and MS, work 4 rows of Double Crochet around neck and front opening. Press gently.

Attach sleeves placing centre of sleeve at shoulder seam. Press. Sew up side and sleeve seams and press.

Småland
Child's skirt and sweater

To the north of Skåne lies Småland – a harsher, less fertile terrain that came under the conflicting influences of both lake and forest. There were local differences in costume even within the province itself, and in the district of Västbo in the nineteenth century, the men would wear a cap, knitted in cotton with red or pink on a white background. The pattern varied from simple stripes, to triangles which frame a distinctive repeated motif that is also peculiar to the district. Because of the colours and the delicate nature of the pattern, I have used the Västbo cap as the basis for a very feminine design – a little girl's outfit in cream and dusky pink. The raglan-sleeved sweater uses the simple border stripes while the triangular pattern decorates the hem of the skirt. The heart-shaped bib carries the delicate Småland motif.

Materials
4 (5) 25g balls of Standard 4-Ply yarn in MS.
4 (5) 25g balls of Standard 4-Ply yarn in C.
1 pair each 2¾mm and 3¼mm needles.
3.25mm crochet hook.
2 buttons in MS.

Measurements
Age 2 to 3 (4 to 5) years
Sweater
To fit chest: 56 (61)cm [22 (24)ins]
Length from top of shoulder: 35 (38)cm [13¾ (15)ins]
Sleeve seam: 23 (27)cm [9 (10½)ins]
Skirt
Length from waist: 28 (34)cm [11 (13½)ins]

Tension
14 sts and 17 rows to 5cm [2ins] measured over st.st using 3¼mm needles.

SKIRT

Back
** With 3¼mm needles and MS, cast on 100 (111) sts. Work border as follows:

First size Row 1: * k1, p1; rep from * to end of row.
Row 2: * p1, k1; rep from * to end of row.
Repeat these 2 rows 2 more times (6 rows).

Second size Row 1: * k1, p1; rep from * to last st, k1.
Repeat this row 7 more times (8 rows).

Both sizes Work 4 rows in st.st.
Join in C and work the 10 rows of border pattern from Chart A, repeating the 11 pattern sts 9 (10) times across, and working the last st on k rows, and the first st on p rows as indicated.
Break off C, and with MS continue straight until back measures 25 (30)cm [10 (12)ins], with right side facing for next row.
Decrease for waist as follows:
k1, * sl 1, k2 tog, psso, k8; rep from * to end of row. 82 (91) sts. **
Change to 2¾mm needles, and k1, p1 rib (2nd size ending with a k st on right side rows) for 6 (8) rows.
Next row: Make buttonholes: Rib 26 (28),

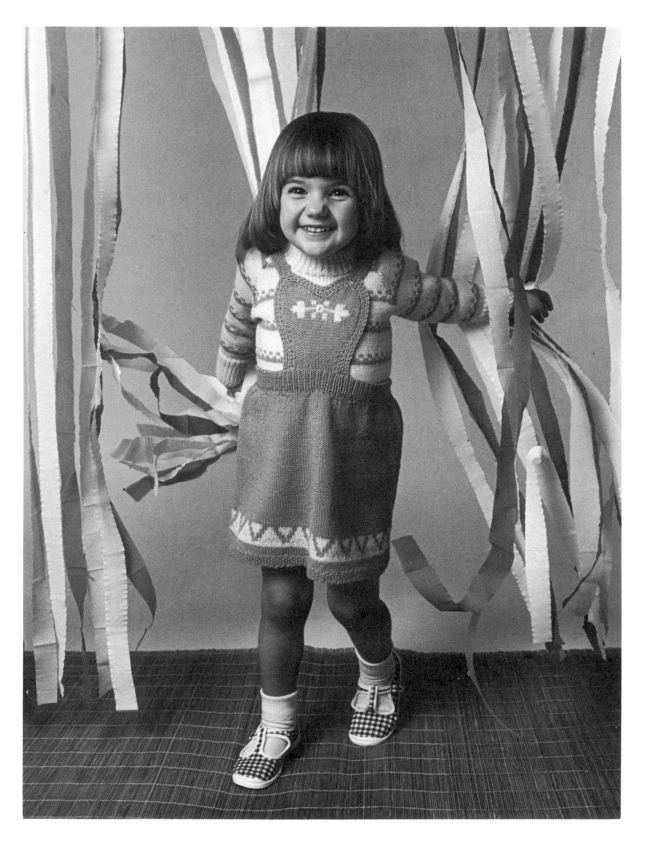

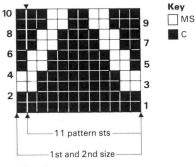

— 11 pattern sts —

1st and 2nd size

Chart A

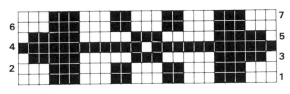

Chart B

k2 tog, yo, rib 26 (31), yo, k2 tog, rib 26 (28).

Continue in rib until back measures 28 (34)cm [11 (13½)ins] from beg, with right side facing for next row.

Cast off evenly in rib.

Front

As back from ** to **.

Change to 2¾mm needles and k1, p1 rib until front measures 28 (34)cm [11 (13½)ins] from beg, with right side facing for next row.

Shape bib Next row: Cast off 31 (34) sts, rib to end of row.

Then cast off 32 (34) sts, rib to end of row.

Change to 3¼mm needles and st.st, and work the remaining 19 (23) sts of bib, increasing 1 st at each end of the first and every foll. alt. row until there are 37 (43) sts.

Purl 1 row.

Then with right side facing, and joining in C, work the motif from Chart B as follows:

Row 1: k6 (9), then work the 25 sts of Chart B, k6 (9).

Row 2: p6 (9), then work the 25 sts of Chart B, p6 (9).

Work all 7 rows of Chart B in this manner.

Break off C and purl 1 row.

Shape bib top (Left side) With right side facing, k18 (21) sts. Leave the remaining sts on a spare needle. Turn, and purl 1 row.

Then decrease 1 st at each end of next

and every foll. alt. row until 10 (11) sts remain.

Work 1 row.

Then decrease 1 st at each end of next and every row until 6 (7) sts remain.

Cast off evenly.

Shape bib top (Right side) With right side facing, pick up the remaining 19 (22) sts from spare needle, and cast off the first st (centre bib). k to end of row.

Purl 1 row.

Then decrease right side as left and cast off evenly.

Finishing

Omitting ribbing, press both pieces using a warm iron and a damp cloth.

Bib edging With right side facing, 3.25mm crochet hook, and beginning at bottom left side, work 4 rows of DC around bib, increasing around tops and decreasing in centre, to accentuate the heart shape. Fasten off and stitch ends of crochet work to cast off edge of rib on either side. Press gently.

Straps With 2¾mm needles and MS, knit up 6 sts from crochet edge at centre tops of bib. Work as follows:

Row 1: * k1, p1; rep from * to end of row.
Row 2: * p1, k1; rep from * to end of row.

Repeat these 2 rows until straps measure 29 (33)cm [11½ (13)ins].

Attach 1 button to end of each strap.

Sew front to back at side seams and press seams.

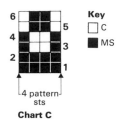

Chart C

Key
□ C
■ MS

4 pattern sts

SWEATER

Back

** With 2¾mm needles and C, cast on 70 (78) sts.

k1, p1 rib for 5cm [2ins].

Next row: Rib 1, m1, rib to the last st, m1, rib 1. 72 (80) sts.

Change to 3¼mm needles and joining in MS, work the 6 rows of pattern from Chart C, repeating the 4 pattern sts 18 (20) times across.

Then break off MS and work 10 rows in C.

Continue in this sequence (6 rows chart/10 rows C), until back measures 24 (25)cm [9½ (10)ins], with right side facing for next row.

Shape armholes Keeping continuity of pattern, cast off 2 sts at beg of next 2 rows. **

Then decrease 1 st at each end of next and every foll. alt. row until 30 (32) sts remain.

Purl 1 row.

Then place the remaining sts onto a length of yarn.

Front

As back from ** to **.

Then decrease 1 st at each end of next and every foll. alt. row until 38 (42) sts remain.

Purl 1 row.

Shape neck With right side facing and keeping continuity of pattern, k2 tog, k8 (10).

Leave remaining sts on a spare needle. Turn, and purl 1 row.

Then decrease 1 st at each end of next and every foll. alt. row until 3 sts remain.

Purl 1 row.

Next row: sl 1, k2 tog, psso, and fasten off.

With right side facing, place the next (centre) 18 sts onto a length of yarn.

Rejoin yarns to the remaining sts, k8 (10), k2 tog.

Purl 1 row.

Continue and decrease this side as left and fasten off.

Sleeves

With 2¾mm needles and C, cast on 38 (42) sts. k1, p1 rib for 5cm [2ins].

Next row: Rib 1, m1, rib to the last st, m1, rib 1. 40 (44) sts.

Change to 3¼mm needles and joining in MS, work the 6 rows of pattern from Chart C, repeating the 4 pattern sts 10 (11) times across.

Break off MS and with C, increase 1 st at each end of next and every foll. 6th row until there are 56 (60) sts. Work chart and st.st sequence as back, working the increased sts into pattern.

Continue straight until sleeve measures 23 (27)cm [9 (10½)ins] from beg, with right side facing for next row.

Shape top Keeping continuity of pattern, cast off 2 sts at beg of next 2 rows. Then decrease 1 st at each end of next and every foll. alt. row until 14 sts remain. Work 1 (3) rows. Place these sts on a length of yarn.

Finishing

Omitting ribbing, press all pieces using a warm iron and a damp cloth. Attach sleeves to back and front at raglan seams, leaving right back/sleeve seam open.

Neckband With 2¾mm needles and C, pick up and knit the 30 (32) sts from back neck, pick up and knit the 14 sts of left shoulder, knit up 6 (7) sts down left side, pick up and knit the 18 sts from front neck, knit up 6 (7) sts up right side, pick up and knit the 14 sts of right shoulder. 88 (92) sts.

k1, p1 rib for 5cm [2ins]. Cast off loosely. Sew up the remaining raglan seam and neckband. Omitting ribbing, press seams.

Fold neckband in half to the inside and catchstitch neatly in position.

Sew up side and sleeve seams and press.

Halland
Woman's jacket

Halland is a coastal province that borders onto the Kattegat. It is in the immediate hinterland of such ports as Gothenburg and Malmo so, like Skåne, it was open to the influence of European fashion, particularly from Paris and Italy. French brocade, bearing what was known as the Scarlet Pimpernel pattern, was imported into Sweden and was particularly prized, being worn by the nobility of Europe. It was also very costly and not within the reach of ordinary people. The Swedes overcame the price barrier by creating a knitted version of the brocade – a prime example of how fabric can inspire knitting. It also shows just how adventurous the Swedish knitters could be, copying something that was both asymmetric and complex.

'Poor Man's Brocade' was knitted in various parts of Sweden, but the name seems quite unworthy of the magnificent pattern and the skill required to make it. The Halland version of the Scarlet Pimpernel was altered to make it just slightly simpler, with the heads of the flowers squared off. I saw it on a costume jacket made around 1840 which obviously took pride of place in someone's wardrobe, and was reserved for only the most special occasions. The jacket was waist-length and close-fitting, the body made from plain navy blue cloth, with the sleeves and shoulders knitted in the Scarlet Pimpernel pattern in brown and yellow. Wrists and borders were worked in diamond mesh and a chequerboard pattern, framed by tiny leaves.

Needless to say, such a tour de force could only give rise to a garment for equally special occasions, and this short, square jacket is designed for when you want to look your best. It is worked all over in Scarlet Pimpernel, while the lapels feature the diamond mesh and the leaves are worked around the borders.

(See colour photograph opposite page 16).

Materials
8 (8, 9, 10) 50g balls of Standard DK in MS.
6 (6, 7, 8) 50g balls of Standard DK in C.
1 pair of 4mm needles.

The yarn used in this garment is Hayfield 'Brig' in Blue with Cream.

Measurements
To fit bust: 81 (86, 91, 97)cm [32 (34, 36, 38)ins]
Length from top of shoulder: 49 (51, 52, 54)cm [19¼ (20, 20½, 21¼)ins]

Sleeve seam: 41 (42, 43, 43)cm [16 (16½, 17, 17)ins]

Tension
11½ sts and 12 rows to 5cm [2ins] measured over pattern, using 4mm needles.

Back
With 4mm needles and MS, cast on 103 (109, 115, 121) sts.

Work in st.st for 3cm [1¼ins], with right side facing for next row.

Make Picot hemline as follows:

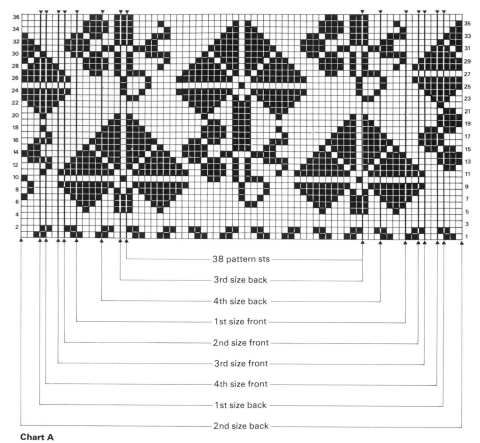

Chart A

Key
□ MS
■ C

k1 * yo, k2 tog; rep from * to end of row.

Purl 1 row. Then joining in C, work the 36 rows of pattern from Chart A, working the first 4 rows once only and thereafter working repeats of rows 5 to 36. Repeat the 38 pattern sts 2 (2, 3, 3) times across, and working the first 13/16/0/3 sts and the last 14/17/1/4 sts on k rows, and the first 14/17/1/4 sts and the last 13/16/0/3 sts on p rows as indicated. Continue in this manner until back measures 30 (31, 31, 32)cm [11¾ (12, 12¼, 12½)ins] from Picot hemline row, with right side facing for next row.

Shape armholes Keeping continuity of pattern, cast off 3 sts at beg of next 2 rows. Decrease 1 st at each end of the next 3 (3, 5, 5) rows. Work 1 row. Then decrease 1 st at each end of next and every foll. alt. row until 85 (91, 95, 99) sts remain.

Continue straight until back measures 49 (51, 52, 54)cm [19¼ (20, 20½, 21¼)ins] from

Picot hemline row, with right side facing for next row.

Shape shoulders Keeping continuity of pattern, cast off 8 (9, 10, 10) sts at beg of next 4 rows. Cast off 10 (10, 9, 10) sts at beg of next 2 rows. Break off C, and with MS, and right side facing, work Picot hemline row as before, along the remaining sts. Work in st.st for 8 rows. Cast off evenly.

Left front
With 4mm needles and MS, cast on 53 (57, 59, 63) sts. Work st.st and Picot hemline row as back. Purl 1 row. Then joining in C, work the 36 rows of pattern from Chart A, working the first 4 rows once only, and thereafter working repeats of rows 5 to 36. Repeat the 38 pattern sts once across, working the first 7/9/10/12 sts and the last 8/10/11/13 sts on k rows, and the first 8/10/11/13 sts and the last 7/9/10/12 sts on

58

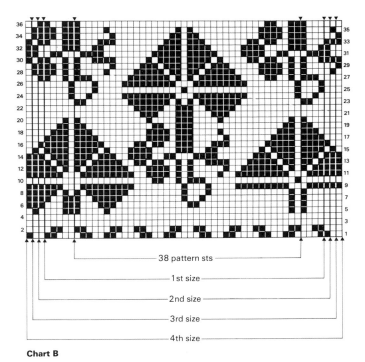

Key
As Chart A

38 pattern sts

1st size

2nd size

3rd size

4th size

Chart B

p rows as indicated. Continue straight until front corresponds with back at beg of armhole shaping, with right side facing for next row.

Shape armhole Keeping continuity of pattern, cast off 3 sts at beg of row, and pattern to end. Work 1 row. Then decrease 1 st at armhole edge of the next 3 (3, 5, 5) rows. Work 1 row. Then decrease 1 st at armhole edge of the next and every foll. alt. row until 44 (48, 49, 52) sts remain. Continue straight until front corresponds with back at beg of shoulder shaping, with right side facing for next row.

Shape shoulder Cast off 8 (9, 10, 10) sts at beg of next and foll. alt. row. Work 1 row. Then cast off 10 (10, 9, 10) sts at beg of next row. Work 1 row. Then cast off the remaining 18 (20, 20, 22) sts.

Right front
As left but reversing all shapings.

Sleeves
With 4mm needles and MS, cast on 47 (49,

51, 53) sts. Work st.st and Picot hemline row as back. Purl 1 row. Then joining in C, work the 36 rows of pattern from Chart B, working the first 4 rows once only, and thereafter working repeats of rows 5 to 36. Repeat the 38 pattern sts once across, working the first 4/5/6/7 sts and the last 5/6/7/8 sts on k rows, and the first 5/6/7/8 sts and the last 4/5/6/7 sts on p rows as indicated. Continue in this manner, increasing 1 st at each end of the 5th (5th, 5th, 9th) pattern row, and then on every foll. 6th (6th, 6th, 5th) row (working increased sts into pattern), until there are 71 (75, 79, 83) sts. Continue straight until sleeve measures 41 (42, 43, 43)cm [16 (16½, 17, 17)ins], with right side facing for next row.

Shape top Cast off 3 sts at beg of next 2 rows. Then decrease 1 st at each end of next and every foll. alt. row until 37 (39, 41, 41) sts remain. Then decrease 1 st at each end of every row until 17 (17, 19, 19) sts remain. Cast off evenly.

Right front facing
With 4mm needles and C, cast on 20 (22,

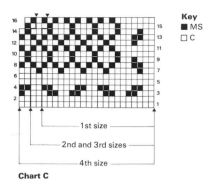

Key
■ MS
□ C

Chart C

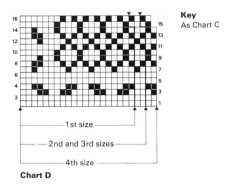

Key
As Chart C

Chart D

22, 24) sts. Work the first 2 rows of Chart C, then join in MS, and continue working the pattern from Chart C, working the first 6 rows once only and thereafter working repeats of rows 7 to 16.

Keeping continuity of pattern, decrease 1 st at the end of row 15 as indicated, and thereafter on every foll. 6th row until 8 (8, 8, 10) sts remain. Continue straight until facing fits neatly in length from top right front to top of hem, when folded at Picot row. Cast off.

Left front facing
Following Chart D, work as right facing, reversing all shapings.

Shoulder pads (2 alike)
With 4mm needles and MS, cast on 20 (22, 22, 24) sts. Work in garter st for 3cm [1¼ins]. Then decrease 1 st at each end of

next and every foll. alt. row until 10 (12, 12, 12) sts remain. Cast off.

Finishing
Press all pieces using a warm iron and damp cloth. Join back and front at shoulder and side seams. Press seams. Fold hem to inside along Picot row. Press, and catchstitch neatly in position. Stitch front hems together. Press gently. Pin wrong side of facings to right sides of fronts, along top and outside edges. Backstitch top and outside edges. Turn facings right side out and press down seams carefully. Pin inside edges of facings to fronts, and catchstitch lightly and neatly in position. Catchstitch bottom of facings to top of hem. Fold hem to inside along Picot row, on back of neck. Press, and catchstitch neatly in position. Sew up sleeve seams then fold sleeve hems to inside along Picot row. Catchstitch neatly in position. Insert sleeves and press seams. Attach shoulder pads.

Dalarna
Woman's Mohair coat

Another adventurous idea comes from the province of Dalarna where the pattern of the men's costume hat was taken from a tie-dyed apron – also traditional and part of the women's costume. The apron was patterned with coloured V's arranged in vertical stripes of red and white. The same stripes decorate the cap, but they are arranged horizontally with extra dashes of colour between the V's. The whole effect is more geometric than the somewhat uneven tie-dyed pattern, and it seems to have survived up to the present day, since vestiges of it can be seen on modern, mass-produced ski-caps.

I decided to use mohair for 'Dalarna', to create a coat that is both luxurious and warm. The tie-dyed V patterns are used, and in reverting to vertical panels I have borrowed as much from the original apron as from the cap. This is not a particularly difficult pattern to work, and it is made easier by the fact that the dashes are embroidered on after the knitting is complete.

(See colour photograph opposite page 17.)

Materials
18 (19, 20) 25g balls of Mohair yarn in MS.
8 (9, 10) 25g balls of Mohair yarn in 1st C.
1 25g ball of Mohair yarn in 2nd C.
1 pair each 4mm and 6½mm needles. 5mm crochet hook.
1 button.

The yarn used in this garment is Sirdar 'Nocturne' Mohair.

Measurements
To fit bust: 81 to 86 (91 to 97, 102 to 107)cm [32 to 34 (36 to 38, 40 to 42)ins]
Length from top of shoulder: 93 (97, 100)cm [36½ (38¼, 39½)ins]
Sleeve seam: 43 (44, 45)cm [17 (17½, 17¾)ins]

Tension
14 sts and 17 rows to 10cm [4ins] measured over st.st using 6½mm needles.

Back
With 6½mm needles and MS, cast on 97 (105, 113) sts.

Work 7 rows in st.st. Then with wrong side facing knit 1 row (hemline). Join in 1st C and work pattern as follows:

Row 1: With MS k6 (10, 14), with C k7, with MS k6, with C k7, with MS k6, with both yarns work the 33 sts of panel from Chart A, with MS k6, with C k7, with MS k6, with C k7, with MS k6 (10, 14).

Row 2: As Row 1, but purl.

Continue in this manner, repeating the 14 rows of panel from Chart A, until back measures 70 (73, 76)cm [27½ (28¾, 30)ins], with right side facing for next row.

Shape armholes Keeping continuity of pattern, cast off 3 sts at beg of next 2 rows. Then decrease 1 st at each end of every row

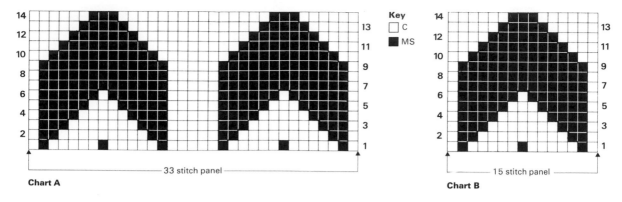

Key
□ C
■ MS

Chart A — 33 stitch panel

Chart B — 15 stitch panel

until 85 (93, 101) sts remain. Work 1 row. Then decrease 1 st at each end of next and every foll. alt. row until 71 (79, 87) sts remain.

Continue straight until armhole measures 13 (14, 14)cm [5 (5½, 5½)ins], with right side facing for next row. Cast off.

Left front

With 6½mm needles and MS, cast on 49 (53, 57) sts.

Work 7 rows in st.st. Then with wrong side facing, knit 1 row (hemline).

Join in 1st C and work pattern as follows:

Row 1: With MS k4 (6, 8), with C k7, with MS k6, with both yarns work the 15 sts of panel from Chart B, with MS k6, with C k7, with MS k4 (6, 8).
Row 2: As Row 1, but purl.

Continue in this manner, repeating the 14 row panel from Chart B, until front corresponds in length with back at armhole, with right side facing for next row.

Shape armhole

Keeping continuity of pattern, cast off 3 sts at beg of next row. Work 1 row. Then decrease 1 st at armhole edge of next and every foll. row until 43 (47, 51) sts remain. Work 1 row. Then decrease 1 st at armhole edge of next and every foll. alt. row until 36 (40, 44) sts remain.

Continue straight until armhole measures 13 (14, 14)cm [5 (5½, 5½)ins], with right side facing for next row. Cast off.

Right front

As left but reversing all shapings.

Yoke (2 pieces alike)

With 6½mm needles and MS, cast on 52 (58, 62) sts.

Work straight in st.st until piece measures 7 (8, 8)cm [2¾ (3, 3)ins], with right side facing for next row.

Shape neck

k14 (17, 19) and place these sts on a spare needle. Cast off the next 24 sts (back neck), k14 (17, 19).

Turn, and work these sts of left shoulder as follows:

Work 5 rows straight. Then increase 1 st at beg (neck edge) of next and every foll. alt. row until there are 17 (20, 22) sts.

Then increase 1 st at neck edge of next and every foll. row until there are 20 (23, 25) sts.

Then cast on 6 sts at neck edge of next row. Work 4 (6, 6) rows straight. Cast off.

With right side facing, pick up the 14 (17, 19) sts from spare needle and work the right shoulder as left, but reversing all shapings.

Work 1 more identical piece.

Sleeves

With 4mm needles and MS, cast on 36 (38, 40) sts.

k1, p1 rib for 8cm [3ins].

Next row: Rib 1 (2, 3) (m1, rib 2) 17 times, M1 rib 1 (2, 3). 54 (56, 58) sts.

Change to 6½mm needles, join in 1st C, and pattern as follows:

Row 1: With MS k21 (22, 23), with C k3, with MS k6, with C k3, with MS k21 (22, 23).
Row 2: As Row 1, but purl.

Continue in this manner, and work straight until sleeve measures 43 (44, 45)cm [17 (17½, 17¾)ins] from beg, with right side facing for next row.

Shape top Cast off 3 sts at beg of next 2 rows. Then decrease 1 st at each end of next and every foll. alt. row until 26 (26, 28) sts remain. Work 1 row. Then decrease 1 st at each end of next and every foll. row until 12 sts remain. Cast off.

Finishing
With 2nd C, embroider dashes onto 1st C stripes, on sleeves, fronts and back (including centre back panel A), as photograph. (See page 125 for embroidery technique.)

Omitting ribbing, press all pieces *very lightly* using a warm iron and a damp cloth.

Using MS and running stitch, sew a length of yarn along top edge of back, and gather evenly, pinning the gathered edge to yoke back (cast on edge). Sew firmly and press lightly.

Sew lengths of yarn along top edge of each front piece as back, and gather evenly, pinning the gathered edges to yoke fronts (cast off edges). Sew firmly and press lightly.

Attach the remaining yoke to coat, on the inside. Pin at back and front yoke seams and catchstitch neatly in position.

Sew back to fronts at side seams and press lightly. Turn hem up at hemline and catchstitch neatly in position. Press lightly.

Sew up sleeve seams and press. Insert sleeves.

Neck and front edging
With right side of work facing, 5mm crochet hook, MS, and beginning at right front hem, work 3 rows of DC up right front, around neck and down left front. Make a loop buttonhole at top of right front, on the last row.

Attach button to top left front.

Key

□ MS red
■ 1st C navy
⊡ 2nd C white
⊠ 3rd C green
▣ 4th C gold

Chart A

Chart B

Sleeves

With $3\frac{1}{4}$mm needles and 1st C, cast on 40 sts. k1, p1 rib for 7cm [$2\frac{3}{4}$ins].

Next row: Rib 6 (m1, rib 2) 14 times, m1, rib 6. 55 sts.

Change to 4mm needles, and joining in and breaking off colours as required, work the 88 rows of pattern from Chart B, using separate balls of yarn for 1st C motifs, as back, and increasing 1 st at each end of 3rd and every foll. 6th pattern row, as indicated, until there are 81 sts. Continue straight to row 88. Then with 1st C cast off knitwise.

Finishing

Omitting ribbing, press all pieces using a warm iron and damp cloth.

Join back and front at right shoulder seam.

Neckband With right side facing, $3\frac{1}{4}$mm needles and 3rd C, knit up 16 sts down front left neck edge, pick up and knit the 20 sts across front neck, knit up 16 sts up right neck edge, knit up 34 sts along back neck. 86 sts.

k1, p1 rib for 4cm [$1\frac{1}{2}$ins]. Cast off evenly in rib.

Sew up left shoulder/neckband seam. Press seams. Attach sleeves, placing centre of sleeve at shoulder seam. Press seams. Sew up side and sleeve seams and press seams.

Hälsingland
Child's dress

This little girl's dress, like the previous pattern, was inspired by the cap described on **page 64**. It uses just the horizontal bands of diamonds to border the hem and the yoke. The dress is knitted in the round, and the Two Yarns Method is used on the hem and yoke edges (see section on Two Yarns Method on page 125).

Materials
3 (4, 6) 50g balls of Standard DK yarn in MS (Red).
1 50g ball of Standard DK yarn in 1st C (Navy).
1 50g ball of Standard DK yarn in 2nd C (White).
1 set of 4 4mm needles, 1 set of 4 3¼mm needles, 4mm crochet hook.
2 navy buttons.

Measurements
Age 1 to 2 (2 to 3, 4 to 5) years
To fit chest: 51 (56, 61)cm [20 (22, 24)ins]
Length from back of neck to hem: 43 (53, 62)cm [17 (21, 24½)ins]
Sleeve seam: 21 (24, 27)cm [8½ (9½, 10½)ins]

Tension
11½ sts and 15 rows to 5cm [2ins] measured over st.st. using 4mm needles.

Skirt
With set of 4mm needles and navy yarn cast on 64 (72, 80) sts on each needle, thus forming a round. Total: 192 (216, 240) sts.

Using the Two Yarns Method (see page 125), work border as follows:

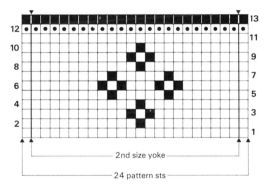

Key
☐ MS red
■ 1st C navy
⊙ 2nd C white

2nd size yoke
24 pattern sts

Round 1: 2 balls navy – purl.
Round 2: 1 ball navy/1 ball white – knit (start with navy).
Round 3: 1 ball white/1 ball navy – purl (start with white).
Round 4: 1 ball navy/1 ball red – knit (start with navy).
Round 5: 1 ball red/1 ball navy – purl (start with red).
Round 6: 2 balls navy – knit.
Round 7: 2 balls navy – purl.

Break off all yarns.
Beginning with red yarn and st.st, and joining in white as required, work the 13

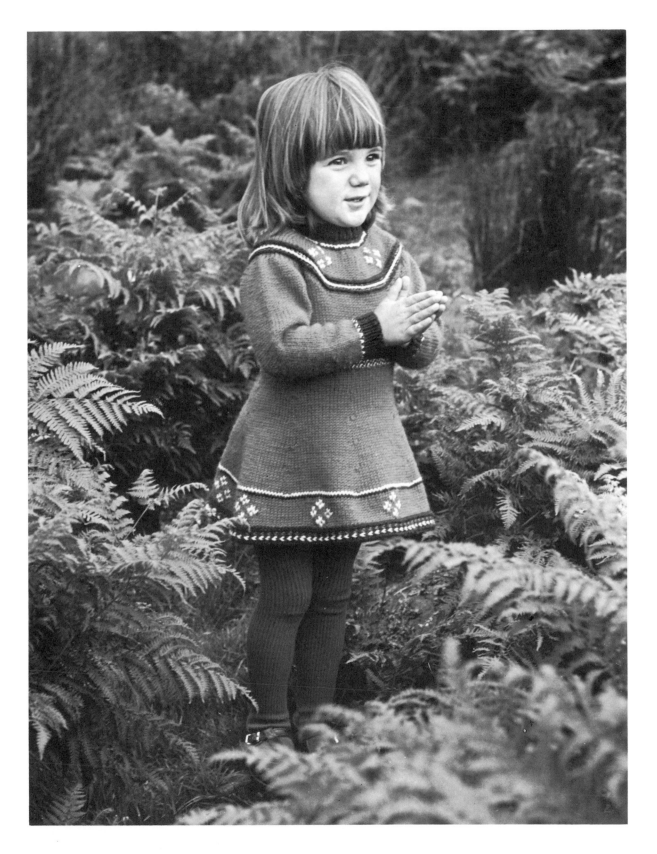

rows of pattern from Chart, repeating the 24 pattern sts 8 (9, 10) times across.

(NB: Split the white yarn into 8 (9, 10) separate balls. See page 125.)

Break off white and work 1 round in red. Then shape skirt as follows:

1st decrease: k10 * ssk, k2 tog, k20; rep from * to the last 10 sts, k10. 176 (198, 220) sts.

Work 8 (11, 14) rounds straight.

2nd decrease: k9 * ssk, k2 tog, k18; rep from * to the last 9 sts, k9. 160 (180, 200) sts.

Work 8 (11, 14) rounds straight.

3rd decrease: k8 * ssk, k2 tog, k16; rep from * to the last 8 sts, k8. 144 (162, 180) sts.

Work 8 (11, 14) rounds straight.

4th decrease: k7 * ssk, k2 tog, k14; rep from * to the last 7 sts, k7. 128 (144, 160) sts.

Work 8 (11, 14) rounds straight.

5th decrease: k6 * ssk, k2 tog, k12; rep from * to the last 6 sts, k6. 112 (126, 140) sts.

Work 8 (11, 14) rounds straight.

Change to $3\frac{1}{4}$mm needles and work in k1, p1 rib as follows:

1 round white, 1 round navy, 1 round white, 5 (7, 9) rounds navy.

Change back to 4mm needles, and with red yarn and st.st, continue straight for 6 (11, 15)cm [$2\frac{1}{2}$($4\frac{1}{4}$, 6)ins].

Divide work into back and front sections as follows:

Place the first 28 (31, 35) sts and the last 28 (32, 35) sts of round together on a spare needle (back). Place the remaining 56 (63, 70) sts together on one needle (front). All further work on skirt is knitted using 2 needles of the set.

Front Work front as follows:

** Cast off 3 sts at beg of next 2 rows.

Next row: k1, k2 tog, k10 (12, 14), k2 tog. Place the next 20 (23, 26) sts on a length of yarn (centre front). Leave the remaining 15 (17, 19) sts on a spare needle.

Next row: Purl 13 (15, 17) sts.

Continue in st.st, decreasing 1 st at each end of next and every foll. alt. row until 3 sts remain. Purl 3. Turn, then sl 1, k2 tog, psso. Draw the yarn through this st to cast off.

Work the remaining 15 (17, 19) sts from spare needle, in the same manner.

Back Pick up and work the remaining 56 (63, 70) sts of back, as front, starting from **.

Sleeves
With navy yarn and $3\frac{1}{4}$mm needles, cast on 11 (11, 12) sts on each needle, thus forming a round. Total: 33 (33, 36) sts.

k1, p1 rib for 9 (9, 11) rounds. Rib 1 round in white.

Change to 4mm needles, red yarn and working in st.st, increase 1 st at beg and end of first and every foll. 6th (6th, 8th) round, until there are 46 (48, 52) sts.

Continue straight until sleeve measures 21 (24, 27)cm [8 ($9\frac{1}{2}$, $10\frac{1}{2}$)ins].

Shape armhole Work the next round to the last 3 sts. Cast off these 3 sts, work to the end of row. Then cast off the first 3 sts of the next round, sl 1, ssk, knit to the last 3 sts, k2 tog, k1. Turn and purl the next row.

Continue in this manner, decreasing 1 st at each end of next and every foll. alt. row until 26 (28, 30) sts remain.

Next row: p3 * p2 tog; rep from * to the last 3 sts, p3. 16 (17, 18) sts.

Place these sts onto a length of yarn.

Press skirt and sleeves lightly. Sew sleeves to body at armhole seams.

Yoke Pick up sts and work yoke as follows:

With 4mm needles, red yarn, and starting at centre back, pick up and knit 10 (11, 13) sts from length of yarn, knit up 12 (13, 14) sts up left back, pick up and knit 16 (17, 18) sts along left sleeve, knit up 12 (13, 14) sts down left front, pick up and knit 20 (23, 26) sts across centre front, knit up 12 (13, 14) sts up right front, pick up and knit 16 (17, 18) sts along right sleeve, knit up 12 (13, 14) sts down right back, then the remaining 10 (12,

13) sts from centre back. 120 (132, 144) sts.
Work the Two Yarns border as follows:

Round 1: 2 balls navy – purl.
Round 2: 2 balls navy – knit.
Round 3 2 balls white – purl.
Round 4: 2 balls navy – knit.
Round 5: 2 balls navy – purl.

Break off all yarns and with red yarn and st.st work 1 (2, 3) rounds straight.

Sizes 51/61cm [20/24ins] Work the first 2 rounds of Chart.

Size 56cm [22ins] Work the first round of Chart. Then work round 2 as indicated on Chart. i.e. omitting sts No. 1 and No. 24.

All sizes Work the remaining rows of Chart, decreasing 1 st between each white design i.e. 5 (6, 6) decreases evenly spaced along the round. Decrease in this manner on every alt. round, until 90 (96, 108) sts remain.

Then with navy yarn work 1 (2, 3) rounds straight.

Make back opening Work all the following rows by turning at centre back:
Knit 1 row navy. Purl 1 row white. Knit 1 row navy. Purl 1 row navy.
Next row: With navy, * k1, k2 tog; rep from * to end of row. 60 (64, 72) sts. Purl 1 row navy, then change to $3\frac{1}{4}$mm needles and k1, p1 rib for 12 (14, 16) rows. Cast off loosely.

Finishing
Fold neckband in half to the inside, and catchstitch neatly in position. With 4mm crochet hook and navy yarn, work 3 rows of DC around back neck opening, making 2 buttonholes on right side of opening. Sew 2 buttons to correspond on the left side.
Press garment lightly with a warm iron and damp cloth.

Delsbø
Woman's sweater

I have shown how contemporary fashion influenced Swedish folk costume to a greater or lesser degree according to how isolated each region was. Around the beginning of the nineteenth century, in the parish of Delsbø in Hälsingland, a new fashion for both men and women emerged, which was centred on Delsbø and nowhere else. It consisted of a sweater or short jacket knitted in what is, quite frankly, the most original and complex colour knitting pattern that I have ever seen. This unique, strikingly effective pattern was knitted by professionals using fine yarn and needles, with red as a main shade and black and green as contrast colours. The main pattern itself is large-scale, and, except with precise mathematical language, it defies description. To me, it represents the ultimate example of the art of the professional knitter.

As to the origins of the Delsbø pattern, there is no information in any Swedish museum and so it remains very much an enigma. It was knitted with several small variations, usually effected by shifting the colour emphasis, or by re-arranging the different design elements, or using one of several alternative border designs. A date and initials were frequently knitted into the chest of the garment and in fact one example that I saw (dated 1840) had two sets of initials, which showed that it was made for someone's wedding day – a clear indication of the special place that the pattern had in local costume.

I so much admired the Delsbø sweaters as examples of knitting, that I decided to base three garments upon them. The first, a sweater, is the most like the original, the shape being kept simple and the body worked all over in the main Delsbø pattern. In addition, one of the floral border designs is used on the yoke and sleeves. I have kept to the original colours of red, black and green, and the contrast yarns are stranded over quite long distances, so careful knitting as well as concentration is required.

(See colour photograph opposite page 80.)

Materials
6 (6, 7, 7, 7) 50g balls of Standard 4-Ply yarn in MS.
4 (4, 5, 5, 5) 50g balls of Standard 4-Ply yarn in 1st C.
2 50g balls of Standard 4-Ply yarn in 2nd C.
1 pair each 2¾mm and 3mm needles.

The yarn used in this garment is Sirdar 'Country Style' 4-Ply in Flamenco with Black and Tartan Green.

Measurements
To fit bust: 81 (86, 91, 97 102)cm [32, (34, 36, 38, 40)ins]
Length from top of shoulder: 58 (58, 60, 60, 61)cm [23 (23, 23½, 23½, 24)ins]
Sleeve seam: 44cm [17½ins] all sizes.

Tension
15 sts and 17 rows to 5cm [2ins] measured over pattern using 3¼mm needles.

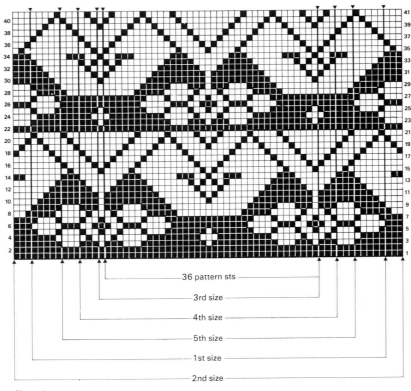

Chart A

Key
□ MS
■ 1st C

Back
* With 2¾mm needles and MS, cast on 112
(118, 124, 132, 138) sts.

k1, p1 rib for 6cm [2½ins].

Next row: Rib 2 (5, 2, 3, 6) [m1, rib 6 (6,
6, 7, 7)] 18 (18, 20, 18, 18) times, m1, rib 2
(5, 2, 3, 6). 131 (137, 145, 151, 157) sts.

Change to 3¼mm needles and joining in
1st. C, work the 41 rows of pattern from
Chart A (working row 1 once only and
thereafter working repeats of rows 2 to 41),
repeating the 36 pattern sts 3 (3, 4, 4, 4)
times across, and working the first
11/14/0/3/6 sts and the last 12/15/1/4/7 sts
on k rows, and the first 12/15/1/4/7 sts and
the last 11/14/0/3/6 sts on p rows as
indicated. Continue in this manner until
back measures 37cm [14½ins].

Shape armhole Keeping continuity of
pattern, cast off 3 sts at beg of next 2 rows.
Decrease 1 st at each end of next 5 (5, 7, 7,

7) rows. Work 1 row. Then decrease 1 st at
each end of every foll. alt. row until 95 (97,
103, 107, 111) sts remain. Pattern straight
until Chart A has been worked 3½ times (row
22 of Chart) and back measures approx.
48cm [19ins]. Work 1 more row in 1st C.
Break off 1st C. Work 1 row in MS, then
joining in and breaking off colours as
required, work the 38 rows of Chart B,
repeating the 20 pattern sts 4 (4, 5, 5, 5)
times across, and working the first
7/8/1/3/5 sts and the last 8/9/2/4/6 sts on
k rows, and the first 8/9/2/4/6 sts and the
last 7/8/1/3/5 sts on p rows as indicated.**

Continue in this manner until back
measures 58 (58, 60, 60, 61)cm [23 (23, 23½,
23½, 24)ins] with right side facing for next
row.

Shape shoulders Cast off 8 (8, 9, 10, 10)
sts at beg of next 4 rows. Cast off 10 (10, 10,
9, 10) sts at beg of next 2 rows. Leave the

73

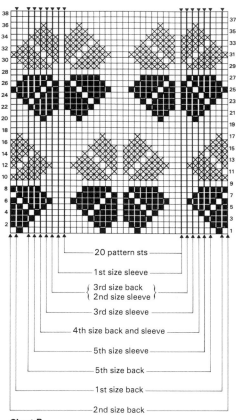

Key
□ MS
■ 1st C
☒ 2nd C

20 pattern sts
1st size sleeve
3rd size back
2nd size sleeve
3rd size sleeve
4th size back and sleeve
5th size sleeve
5th size back
1st size back
2nd size back

Chart B

remaining 43 (45, 47, 49, 51) sts on a spare needle.

Front
As back from * to **.

Continue in this manner until front measures 54 (54, 55, 55, 56)cm [21¼ (21¼, 21¾, 21¾, 22)ins], with right side facing for next row.

Shape neck Pattern 35 (35, 37, 38, 39) sts. Leave remaining sts on a spare needle. Turn, and keeping continuity of pattern, work these sts of left shoulder, decreasing 1 st at neck edge of next 6 (6, 4, 4, 4) rows. Then decrease 1 st at neck edge of every foll. alt. row until 26 (26, 28, 29, 30) sts remain. Pattern straight until front corresponds with back at shoulder edge, with right side facing for next row.

Shape shoulder Cast off 8 (8, 9, 10, 10) sts at shoulder edge of next and foll. alt. row. Work 1 row. Cast off the remaining 10 (10, 10, 9, 10) sts. With right side of work facing, place the centre 25 (27, 29, 31, 33) sts (front neck) on a length of yarn. Rejoin yarns to remaining 35 (35, 37, 38, 39) sts of right shoulder, and pattern to end of row. Work as left shoulder but reversing all shapings.

Sleeves
With 2¾mm needles and MS, cast on 56 (58, 60, 62, 64) sts.

k1, p1 rib for 6cm [2½ins].

Next row: Rib 6 (7, 8, 9, 10), (m1, rib 11) 4 times, m1, rib 6 (7, 8, 9, 10). 61 (63, 65, 67, 69) sts.

Change to 3¼mm needles, and joining in and breaking off colours as required, work the 38 rows of pattern from Chart B,

repeating the 20 pattern sts 3 times across, and working the first 0/1/2/3/4 sts and the last 1/2/3/4/5 sts on k rows, and the first 1/2/3/4/5 sts and the last 0/1/2/3/4 sts on p rows as indicated. Continue in this manner, and increase 1 st at each end of the 4th (4th, 2nd, 4th, 4th) pattern row. Then increase 1 st at each end of every foll. 9th (8th, 8th, 7th, 6th) row until there are 87, (91, 95, 101, 107) sts (working increased sts into pattern). Pattern straight until sleeve measures 44cm [17½ins], with right side facing for next row.

Shape top Keeping continuity of pattern, cast off 3 sts at beg of next 2 rows. Decrease 1 st at each end of next and every foll. alt. row until 31 (33, 35, 37, 39) sts remain. Work 1 row. Then decrease 1 st at each end of every row until 21 (21, 23, 23, 23) sts remain. Cast off.

Finishing
Omitting ribbing, press all pieces using a warm iron and damp cloth. Join right shoulder seam.

Neckband With right side of work facing, 2¾mm needles and MS, knit up 14 (14, 16, 16, 16) sts down left side of neck, knit 25 (27, 29, 31, 33) sts across front neck, knit up 14 (14, 16, 16, 16) sts up right side of neck, knit 43 (45, 47, 49, 51) sts across back neck. 96 (100, 108, 112, 116) sts.

k1, p1 rib for 5cm [2ins]. Cast off loosely in rib.

Join left shoulder seam and neckband. Fold neckband in half to wrong side, and catchstitch neatly in position.

Join side and sleeve seams. Insert sleeves. Press seams.

Delsbø
Woman's mohair jacket

This mohair jacket is the second garment inspired by the Delsbø sweater described on page 72. It was the result of picking out just a single feature of the pattern and then letting my imagination run. I have taken a linear section of the original and enlarged it to follow the whole shape of the jacket, so it is completely non-repetitive. The use of mohair adds a new dimension and slightly softens the geometric lines, while the two colours used are very different from the original.

(See colour photograph opposite page 81.)

Materials
9 25g balls of Mohair yarn in MS.
6 25g balls of Mohair yarn in C.
1 pair 5½mm needles. 5mm crochet hook.
1 hook/eye fastening. 2 buttons.

Measurements
To fit bust: 81 to 86cm [32 to 34ins]
Length from top of shoulder: 55cm [21½ins]
Sleeve seam: 41cm [16ins]

Tension
15 sts and 18 rows to 10cm [4ins] measured over st.st using 5½mm needles.

Back
With 5½mm needles and MS, cast on 72 sts. Work in st.st for 7 rows.

Then with wrong side facing, knit 1 row (hemline).

Join in C (using separate balls of yarn for each section of colour, i.e. 3 balls in C, 2 balls in MS. See Jacquard Technique on page 125) and work the 72 sts and 96 rows of pattern from Chart A, shaping armholes on rows 65 to 68, and casting off for back neck on row 95, as indicated on Chart. Cast off at shoulders.

Left Front
With 5½mm needles and MS, cast on 36 sts. Work 7 rows in st.st. Then with wrong side facing, knit 1 row (hemline).

Join in 2 balls of C, and work the 36 sts and 96 rows of left front pattern from Chart A, shaping armhole on rows 65 and 67. Shape neck on row 88, and decrease neck edge as indicated on Chart. Cast off at shoulder.

Right front
As left, but reversing all shapings, as indicated on Chart A.

Sleeves
With 5½mm needles and MS, cast on 60 sts. Work 7 rows in st.st. Then with wrong side facing, knit 1 row (hemline).

Join in 2 separate balls of C, and work the 60 sts and 103 rows of pattern from Chart B, shaping top as indicated on Chart. Cast off.

Finishing
Press all pieces *very lightly* using a warm iron and damp cloth. Join back and fronts at shoulder seams and press lightly. Sew up side and sleeve seams and press lightly.

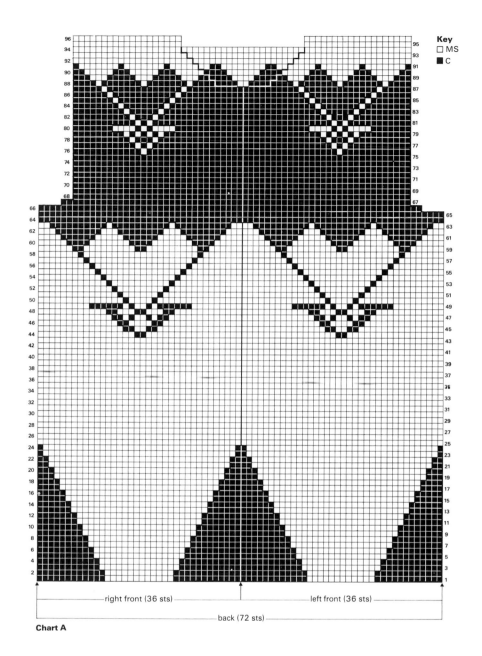

Chart A

Key
□ MS
■ C

right front (36 sts)

left front (36 sts)

back (72 sts)

Turn hem up at hemline on body and sleeves. Catchstitch neatly and press lightly. Insert sleeves.

Front neck edging With right side facing, 5mm crochet hook, and beginning with C (change the colours to correspond with pattern), work 5 rows of DC, starting at bottom right front and finishing at bottom left front. Press edging lightly.

Button covers With 5mm crochet hook and MS, work 2 circular pieces in DC, and cover the buttons. Attach 1 button to each side of neck. Attach hook/eye fastening to top neck, on the inside.

Shoulder pads (2 alike) With $5\frac{1}{2}$mm needles and using 2 strands of MS, cast on 20 sts.

Knit 12 rows in garter st. Then decrease

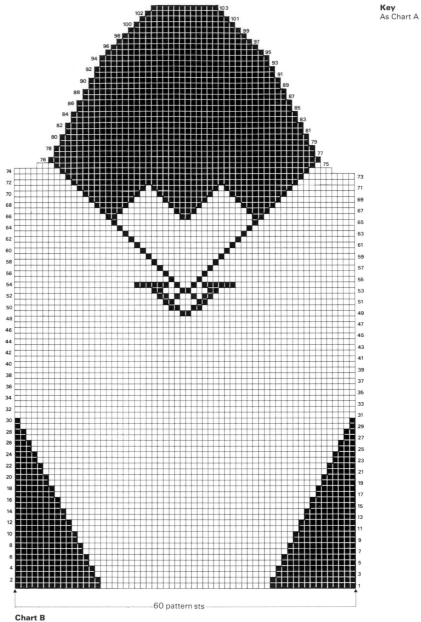

60 pattern sts

Chart B

1 st at each end of next and every foll. row until 8 sts remain. Cast off.

Insert shoulder pads and catchstitch along shoulder seams.

Brush the garment lightly and evenly using a teazle brush.

Delsbø
Woman's blouse

This blouse is the final garment taken from the same idea that inspired the last two patterns. It uses one of the Delsbø borders, repeated all over in horizontal rows. It is framed at hem, sleeves and collar with a garter stitch chequerboard pattern that was used on the original to trim the neck and cuffs.

It says much for the Delsbø pattern that it can inspire three garments which look so completely different – one fairly accurate version of the original (the sweater on page 72), and two much looser and more fanciful adaptations (the previous pattern and this blouse). It could have inspired many, many more.

Materials
7 (8) 25g balls of Standard 4-Ply yarn in MS.
4 (5) 25g balls of Standard 4-Ply yarn in C.
1 pair each 3mm and $3\frac{3}{4}$mm needles.
4 10mm buttons.

Measurements
To fit bust: 81 to 86 (91 to 97)cm [32 to 34 (36 to 38)ins]
Length from top of shoulder: 52 (56)cm [$20\frac{1}{2}$ (22)ins]
Sleeve seam: 17cm [$6\frac{3}{4}$ins]

Tension
14 sts and 15 rows to 5cm [2ins] measured over pattern using $3\frac{3}{4}$mm needles.

Back
** With 3mm needles and MS, cast on 110 (126) sts.

Join in C and work border as follows:

Row 1: (Right side) * k2 MS, k2 C; rep from * to last 2 sts, k2 MS.
Row 2: * k2 MS, yf, k2 C, yf; rep from * to last 2 sts, k2 MS.

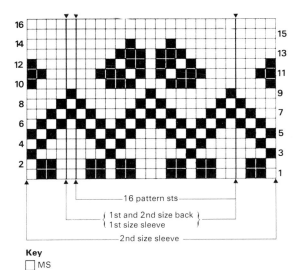

16 pattern sts

1st and 2nd size back
1st size sleeve

2nd size sleeve

Key
□ MS
■ C

Row 3: * k2 C, k2 MS; rep from * to last 2 sts, k2 C.
Row 4: * k2 C, yf, k2 MS, yf; rep from * to last 2 sts, k2 C.

Repeat these 4 rows until border measures 3 cm [$1\frac{1}{4}$ins], with right side facing for next row. Break off C.

Change to $3\frac{3}{4}$mm needles, and with MS,

79

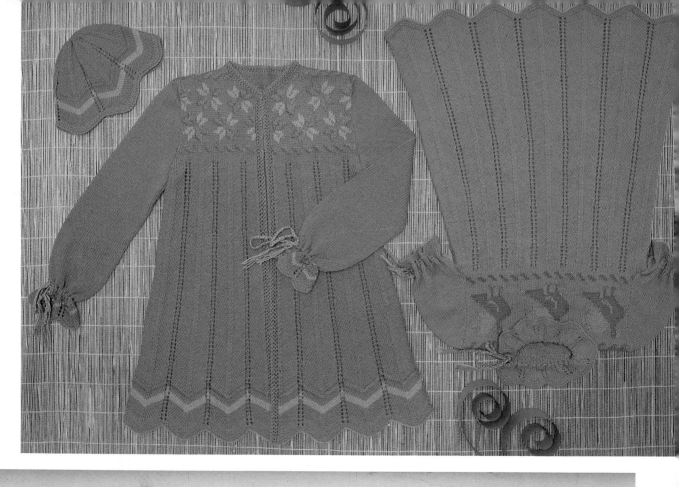
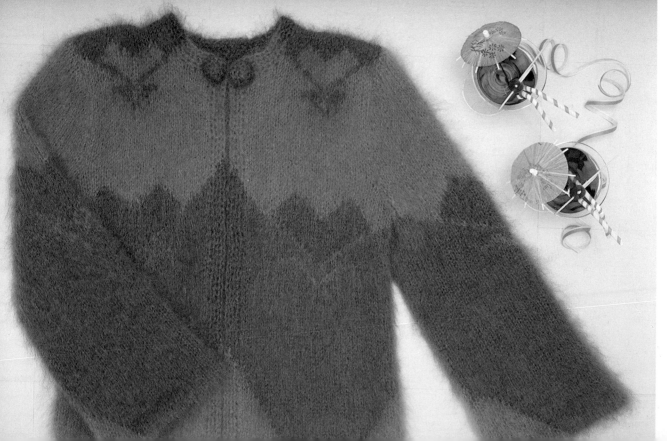

increase as follows:

k1 (9) (m1, k6) 18 times, m1, k1 (9). 129 (145) sts.

Purl 1 row.

Join in C and work the 16 rows of pattern from Chart, repeating the 16 pattern sts 8 (9) times across, and working the last st on k rows and the first st on p rows as indicated.

Continue in this manner until back measures 32 (34)cm [12½ (13½)ins], with right side facing for next row.

Shape armholes Keeping continuity of pattern, cast off 4 sts at beg of next 2 rows. Then decrease 1 st at each end of next and every foll. alt. row until 101 (117) sts remain.**

Continue straight until armhole measures 13 (15)cm [5 (6)ins], with right side facing for next row.

Divide for back neck opening as follows:
Pattern 50 (58) sts. Leave the remaining 51 (59) sts on a spare needle. Turn, and work the first 50 (58) sts straight, until armhole measures 19 (21)cm [7½ (8¼)ins], with right side facing for next row.

Shape shoulder Cast off 8 (9) sts at beg of next and every foll. alt. row until 26 (31) sts remain. Work 1 row.

Then cast off 7 (8) sts at beg of next row. Work 1 row.

Cast off the remaining 19 (23) sts (back neck).

With right side facing, pick up the 51 (59) sts from spare needle and cast off the first (centre back) st. Work this side as previous, but reversing all shapings.

Front
As back from ** to **.

Continue straight until armhole measures 16½ (18)cm [6¼ (7)ins], with right side facing for next row.

Shape neck/left shoulder Pattern 39 (46) sts. Leave the remaining 62 (71) sts on a spare needle. Keeping continuity of pattern, turn and work these 39 (46) sts, decreasing 1 st at neck edge of next and every foll. row

until 31 (35) sts remain. Continue straight until armhole corresponds in length to back armhole, with right side facing for next row.

Shape shoulder Cast off 8 (9) sts at beg of next and every foll. alt. row until 7 (8) sts remain. Work 1 row. Then cast off the remaining sts.

Neck/left shoulder With right side facing, cast off the next (centre) 23 (25) sts from spare needle. Then knit across the remaining 39 (46) sts. Turn and work the left shoulder as right, but reversing all shapings.

Sleeves
With 3mm needles and MS, cast on 70 (78) sts. Work border pattern as back, until border measures 3cm [1¼ins], with right side facing for next row. Break off C.

Change to 3¾mm needles and with MS, increase as follows:

k1, m1, k2 [m1, k7 (8)] 9 times, m1, k4 (3). 81 (89) sts.

Purl 1 row.

Join in C and work the 16 rows of pattern from Chart, repeating the 16 pattern sts 5 times across, and working the first 0/4 sts and the last 1/5 sts on k rows, and the first 1/5 sts and the last 0/4 sts on p rows as indicated. Continue in this manner until sleeve measures 17cm [6¾ins], with right side facing for next row.

Shape top Cast off 4 sts at beg of next 2 rows. Then decrease 1 st at each end of next and every foll. alt. row until 35 (39) sts remain. Purl 1 row.

Cast off 2 sts at beg of next 4 (6) rows. Then cast off 4 sts at beg of next 4 rows. Cast off the remaining 11 sts.

Collar (2 pieces alike)
With 3mm needles and MS, cast on 74 (78) sts.

Join in C and work border pattern as back, until collar measures 4cm [1½ins], with right side facing for next row. Break off C and with MS, cast off evenly. Work 1 more identical piece.

OPPOSITE ABOVE: Suomi (page 89).
OPPOSITE BELOW: Delsbø jacket (page 76).

81

Back neck opening With right side facing, 3mm needles and MS, knit up 26 sts evenly along right side of opening. Knit 3 rows in garter st. Cast off evenly.

Knit up 26 sts evenly along left side of opening, and knit 1 row.

Next row: Make Buttonholes: * k4, k2 tog, yo; rep from * to the last 2 sts, k2.

Knit 1 more row. Cast off evenly.

Finishing

Press all pieces using a warm iron and damp cloth. Sew back to front at shoulder seams and press.

Attach collar pieces to neck, pinning 1 piece to each side, meeting at centre front.

Sew up side and sleeve seams. Press seams. Insert sleeves and sew buttons to back neck opening, to correspond with buttonholes.

Jämtland
Man's V-neck sweater

The design on this sweater, with V-neck and saddle sleeves, was taken from another extremely localised pattern, found on a sock from the province of Jämtland. The sock was knitted in natural, undyed colours of brown and cream, and the vertical stripes and waves are fairly simple by Swedish standards. The patterns of Jämtland tend to be small and geometrical, with many squares and diamonds, and this, combined with their preference for just two natural colours, strongly evokes the Norwegian style. The province does in fact lie on the border with Norway, directly level with Trøndelag, so there could be a connection – although I have no direct evidence for it. Norway is extremely narrow at this point and the westernmost part of Jämtland is only 40 miles from the Norwegian coast, while Selbu lies only 30 miles away.

I kept to earthy colours for this sweater, using cream and peaty brown, and adding narrow stripes at hem, cuffs and neck.

Materials
4 (4, 5, 5, 6) 50g balls of Standard DK yarn in D.
4 (4, 5, 5, 6) 50g balls of Standard DK yarn in L.
1 pair each $3\frac{1}{4}$mm and 4mm needles.

The yarn used in this garment is Sirdar 'Countrystyle' DK in Cream and Peat.

Measurements
To fit chest: 91 (97, 102, 107, 112)cm [36 (38, 40, 42, 44)ins]
Length from top of shoulder: 63 (65, 66, 67, 69)cm [25 ($25\frac{1}{2}$, 26, $26\frac{1}{2}$, 27)ins]
Sleeve seam: 46 (46, 47, 47, 48)cm [18 (18, $18\frac{1}{2}$, $18\frac{1}{2}$, 19)ins]

Tension
12 sts and 12 rows to 5cm [2ins] measured over pattern and using 4mm needles.

Special abbreviations
D = Dark Shake
L = Light Shade

Back
* With $3\frac{1}{4}$mm needles and D cast on 102 (110, 116, 124, 130) sts.

k1, p1 rib, working in stripes of 2 rows D, 2 rows L, for 8cm [3ins].

Next row: Rib 1 (1, 4, 3, 2) [m1, rib 11 (12, 12, 13, 14)] 9 times, m1, rib 2 (1, 4, 4, 2). 112 (120, 126, 134, 140) sts.

Change to 4mm needles and joining in both shades, work the 12 rows of pattern from Chart, repeating the 14 pattern sts 8 (8, 9, 9, 10) times across, and working the first and last 0/4/0/4/0 sts on every row as indicated. Continue in this manner until back measures 42 (43, 43, 43, 43)cm [$16\frac{1}{2}$ (17, 17, 17, 17)ins] with right side of work facing for next row.

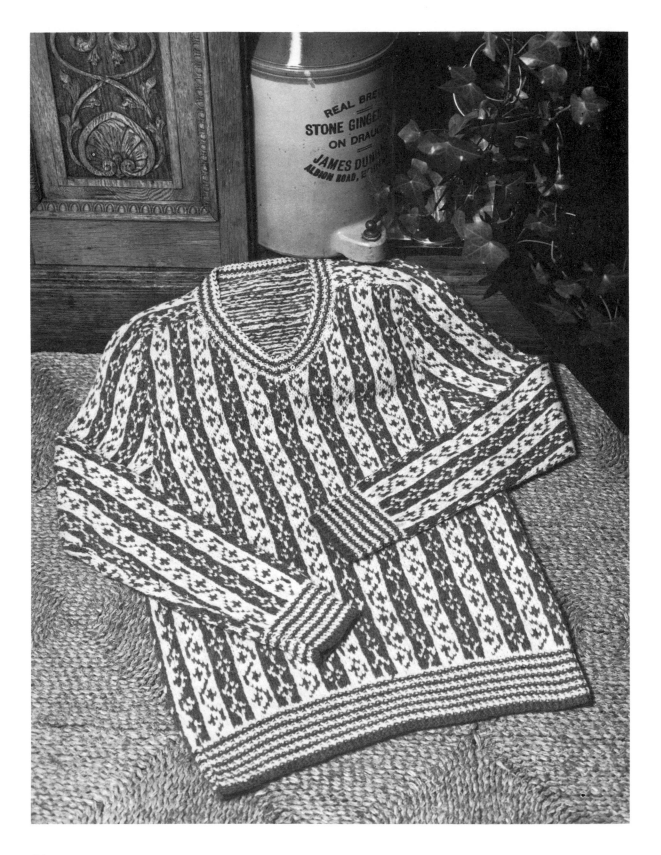

84

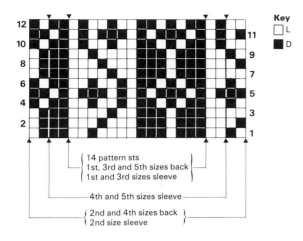

Key
□ L
■ D

14 pattern sts
1st, 3rd and 5th sizes back
1st and 3rd sizes sleeve

4th and 5th sizes sleeve

2nd and 4th sizes back
2nd size sleeve

Shape armholes Keeping continuity of
pattern, cast off 3 sts at beg of next 2 rows.
Then decrease 1 st at each end of the next 5
(7, 7, 9, 9) rows. 96 (100, 106, 110, 116) sts
remaining. Work 1 row. Then decrease 1 st
at each end of next and every foll. alt. row
until 90 (94, 98, 102, 108) sts remain.**

Continue straight until back measures 58
(60, 61, 62, 64)cm [23 (23½, 24, 24½, 25)ins].

Shape shoulders Cast off 12 (12, 13, 13,
14) sts at beg of next 2 rows. Then cast off
12 (13, 13, 14, 15) sts at beg of next 2 rows.
Work the remaining 42 (44, 46, 48, 50) sts
for a further 5cm [2ins], then cast off.

Front
As back from * to **.

Continue straight until front measures 48
(50, 51, 52, 54)cm [19 (19½, 20, 20½, 21)ins],
with right side of work facing for next row.

Shape neck Keeping continuity of pattern,
work 43 (45, 47, 49, 52) sts, k2 tog. Place
remaining sts on a spare needle. Turn, and
work the sts of left shoulder, decreasing 1 st
at neck edge of every row until 24 (25, 26,
27, 29) sts remain. Work straight until
shoulder corresponds with back, with right
side of work facing for next row.

Shape shoulder Cast off 12 (12, 13, 13, 14)
sts at beg of row. Work 1 row. Cast off

remaining 12 (13, 13, 14, 15) sts. With right
side of work facing, rejoin yarns to
remaining sts, k2 tog, pattern to end.

Complete to correspond with left shoulder,
reversing all shapings.

Right sleeve
* With 3¼mm needles and D, cast on 52 (52,
52, 54, 54) sts.

k1, p1 rib in stripe sequence as back and
front, for 8cm [3ins].

Next row: Rib 1 (1, 1, 2, 2) [m1, rib 17
(17, 17, 10, 10)] 3 (3, 3, 5, 5) times, m1, rib
0 (0, 0, 2, 2). 56 (56, 56, 60, 60) sts.

Change to 4mm needles, joining in both
shades, work the 12 rows of pattern from
Chart, repeating the 14 pattern sts 4 times
across, and working the first and last
0/0/0/2/2 sts on every row as indicated.
Continue and shape sleeve by increasing 1 st
at each end of 5th (5th, next, 3rd, 3rd) and
every foll. 4th (4th, 4th, 5th, 5th) row, until
there are 86 (88, 90, 96, 98) sts (working
increased sts into pattern). Then pattern
straight until sleeve measures 46 (46, 47, 47,
48)cm [18 (18, 18½, 18½, 19)ins], with right
side of work facing for next row.

Shape top Keeping continuity of pattern,
cast off 3 sts at beg of next 2 rows. Decrease 1
st at each end of next and every foll. 4th row
until 76 (76, 78, 86, 86) sts remain. Work 1
row. Then decrease 1 st at each end of next
and every foll. alt. row until 28 sts remain.
Continue working these 28 sts for saddle,
until strip, when slightly stretched, fits along
shoulder edge, ending with right side facing
for next row.**

Break yarn, slip 14 sts onto a spare needle,
rejoin yarn and cast off remaining sts.

Left sleeve
As right sleeve from * to **.

Cast off 14 sts. Leave remaining sts on a
spare needle.

Finishing
Omitting ribbing, press all pieces using a
warm iron and damp cloth. Join side and

sleeve seams. Insert sleeves, sewing saddle strip of right sleeve only along shoulders of back and front, and casting off sts to extra rows at top of back. Then sew saddle strip of left sleeve to front only.

Neck border With right side of work facing, $3\frac{1}{4}$mm needles and L, knit 14 sts from left shoulder saddle, then knit up 21 sts down left side of neck (35 sts). Work k1, p1 rib in stripe sequence, for 12 rows. Cast off evenly in rib. With right side of work facing, $3\frac{1}{4}$mm needles and L, knit up 21 sts up right side of neck, knit 14 sts of right shoulder saddle, then knit 42 (44, 46, 48, 50) sts from back neck. 77 (79, 81, 83, 85) sts. k1, p1 rib in stripe sequence as left side. Cast off evenly in rib. Sew saddle strip of left sleeve to back, then join neck border. Catch down ends of neck border at front, crossing left over right.

Finland
East Meets West

When we speak of Finland we are speaking of a country at the farthest edge of Europe – at a dividing line. Not only is it geographically remote, but its tongue-twisting language is similar to nothing spoken in the West. For centuries, its major role was that of a buffer between the more powerful states of Sweden and Tsarist Russia. Although it is a part of Europe and Scandinavia, Finland owes as much in historical and cultural terms to the East as to the West. And, where knitting is concerned, it shows.

The first two keywords for Finnish knitting are colour and variety. Examples can be found of both the geometric and the more free-flowing styles. Indeed, because of the common 'Textile Connection', many of the traditional Finnish design elements are identical to those of Norway –

Glove from the National Museum, Helsinki, used for Karelia (page 109).

Pair of Russian children's socks, used for Astrakan (page 120).

the diamond, the cross, the swastika and the eight-petal rose. However, it is fascinating to note how national character has altered the way these designs are used. Two-colour knitting does form a part of their varied repertoire, but the main strength of Finnish designs lies in their exciting use of colour, creating an effect that is truly exotic and warm. Natural dyes were used adventurously, but any of the motifs mentioned above are just as likely to appear in shocking pink or bright lime green, so the effects vary from the subtle to the extremely bold. Up to four colours were frequently used in a single row, so the colourwork was often complicated.

This daring use of colour reflects a general characteristic of all Finnish design. If any criticism can be levelled against the Scandinavian designers, it is that their work sometimes tends to be just a little stark or antiseptic. Not so the Finns. Their products have all the Scandinavian virtues, but they also have something extra – an affinity for deep, warm colours that shows a touch of Eastern influence.

The Finns also show some liking for extravagance in design, and for luxury and decoration for its own sake – a characteristic that could never be attributed to the solidly practical Norwegians and Swedes. Another keyword for Finnish knitting is therefore richness, which is the only way to describe the almost Oriental flavour created by their use of colour, pattern and embellishment. Gloves, for example, may be decorated with tassles on the fingertips – a fancy flourish which is quite redundant in practical terms, but which adds an aura of richness and festivity.

I have sought to capture the full range of these Finnish qualities in the garments that follow. Several of them are based on museum items about which nothing whatsoever is known, apart from their Finnish origin. The patterns remain excellent examples of unusual and skillfully worked hand-knitting.

Suomi

Child's coat, hat and dress

Suomi simply means Finland. Of all the glove patterns that I saw, there was one in particular that seemed to summarise all the many different features of Finnish knitting, both in colour and pattern design. The glove was bright and colourful, decorated with birds in pink and green and bordered by flowers. There was also a typical chevron pattern on the cuff, accompanied by zig-zag stripes.

All these features are used in this little girl's outfit of hat, coat and dress. The chevron pattern is worked on the main body of each item, and there is a chevron trim on cuffs, collar and sleeves. The bright bird motifs are repeated across the yoke of the dress, and the yoke of the coat has the floral borders. The colours I chose were soft, spring-like shades of green, pink and blue. Suomi is very Finnish and very feminine – the perfect outfit for a special occasion.

(See colour photograph opposite page 81.)

Materials
12 25g balls of Standard 4-Ply yarn in dusky green.
10 25g balls of Standard 4-Ply yarn in pink.
1 25g ball of Standard 4-Ply yarn in light green.
1 25g ball of Standard 4-Ply yarn in blue.
1 pair 3½mm needles. 3.5mm crochet hook.

Measurements
To fit chest: 66cm [26ins]
Length from top of shoulder: 66cm [26ins]
Sleeve seam (coat): 35cm [13¾ins]
Sleeve seam (dress): 7cm [2¾ins]

Tension
13 sts and 18 rows to 5cm [2ins] measured over st.st using 3½mm needles.

COAT

Back
** With 3½mm needles and blue, cast on 162 sts. Knit 4 rows in garter st. Work pattern as follows:

Row 1: * k1, yo, k9, k2 tog, sl 1, k1, psso, k9, yo; rep from * to the last st, k1.
Row 2 (and all wrong side rows): Purl.

Repeat these 2 rows and work stripe sequence as follows:
 4 rows blue/8 rows dusky green/4 rows light green/4 rows dusky green/2 rows pink.
 Break off contrast yarns and with dusky green, continue until back measures 18cm [7ins] from beg, with right side facing for next row.
 (NB: Always measure from point formed by pattern.)

Work the 1st decrease as follows:
 * k1, yo, ssk, k7, k2 tog, sl 1, k1, psso, k7, k2 tog, yo; rep from * to the last st, k1.
148 sts.
 Continue straight in pattern (each side of chevrons having 1 st less) until back measures

89

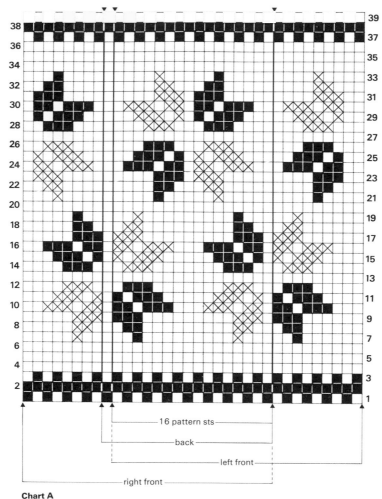

Chart A

Key
- ☐ dusky green
- ■ pink
- ⊠ light green

16 pattern sts

back

left front

right front

30cm [12ins], with right side facing for next row.

Work 2nd decrease as follows:
* k1, yo, ssk, k6, k2 tog, sl 1, k1, psso, k6, k2 tog, yo; rep from * to the last st, k1. 134 sts.

Continue straight in pattern until back measures 41cm [16ins] with right side facing for next row.

Work 3rd decrease as follows:
* k1, yo, ssk, k5, k2 tog, sl 1, k1, psso, k5, k2 tog, yo; rep from * to the last st, k1. 120 sts.

Continue straight in pattern until back measures 48cm [19ins], with right side facing for next row.

Work 4th decrease as follows:
* k1, yo, ssk, k4, k2 tog, sl 1, k1, psso, k4, k2 tog, yo; rep from * to the last st, k1. 106 sts.

Continue straight in pattern until back measures 51cm [20ins], with right side facing for next row.

Work 5th decrease as follows:
* k1, yo, ssk, k3, k2 tog, sl 1, k1, psso, k3, k2 tog, yo; rep from * to the last st, k1. 92 sts.

Purl 1 row.

Shape armholes Working in st.st, cast off 4 sts at beg of next 2 rows.**

Next row: Cast off 2 sts, knit to the end of row.

Next row: Cast off 1 st, purl to the end of row. 81 sts.

Join in pink, then light green, and work the 39 rows of pattern from Chart A, repeating the 16 pattern sts 5 times across, and working the last st on k rows and the first st on p rows as indicated.

Break off contrast yarns and with dusky green, purl 1 row.

Shape shoulders Cast off 7 sts at beg of next 2 rows. Then cast off 8 sts at beg of next 4 rows. Cast off the remaining 35 sts (back neck).

Left front
With 3½mm needles and blue, cast on 82 sts. Knit 4 rows in garter st. Work pattern as follows:

Row 1: * k1, yo, k9, k2 tog, sl 1, k1, psso, k9, yo; rep from * to the last 13 sts, k1, yo, k9, k2 tog, k1.

Row 2 (and all wrong side rows): Purl. Repeat these 2 rows and work stripe sequence as back.

Break off contrast yarns and with dusky green, continue until back measures 18cm [7ins], with right side facing for next row.

Work 1st decrease as follows:
* k1, yo, ssk, k7, k2 tog, sl 1, k1, psso, k7, k2 tog, yo; rep from * to the last 13 sts, k1, yo, ssk, k7, k2 tog, k1. 75 sts.

Continue and decrease in this manner, in the appropriate places, as back, i.e.:
2nd decrease at 30cm [12ins]. 68 sts.
3rd decrease at 41cm [16ins]. 61 sts.
4th decrease at 48cm [19ins]. 54 sts.
5th decrease at 51cm [20ins]. 47 sts.
Purl 1 row.

Shape armhole Cast off 4 sts, knit to the end of row. Purl 1 row.

Then cast off 2 sts, knit to the end of row. Purl 1 row. 41 sts.

Join in pink, then light green, and work the pattern from Chart A, repeating the 16 pattern sts 2 times across, and working the

first 9 sts on k rows and the last 9 sts on p rows as indicated.

Continue in this manner to row 30 of Chart.

Shape neck Keeping continuity of pattern, cast off 6 sts at beg of row 30, pattern to the end of row.

Next row: Pattern to the last 2 sts, k2 tog.

Next row: Cast off 4 sts, pattern to the end of row.

Work the remaining 7 rows of Chart, decreasing 1 st at neck edge of every row. 23 sts.
Purl 1 row.

Shape shoulder Cast off 7 sts, knit to the end of row. Purl 1 row.

Then cast off 8 sts at beg of next and foll. alt. rows.

Right front
With 3½mm needles and blue, cast on 82 sts. Knit 4 rows in garter st.

Work pattern as follows:
Row 1: k1, sl 1, k1, psso, k9, yo, * k1, yo, k9, k2 tog, sl 1, k1, psso, k9, yo; rep from * to the last st, k1.

Row 2 (and all wrong side rows): Purl. Repeat these 2 rows and work stripe sequence as back.

Break off contrast yarns, and continue until front measures 18cm [7ins], with right side facing for next row.

Work 1st decrease as follows:
k1, sl 1, k1, psso, k7, k2 tog, yo, * k1, yo ssk, k7, k2 tog, sl 1, k1, psso, k7, k2 tog, yo; rep from * to the last st, k1. 75 sts.

Continue and decrease in this manner, in the appropriate places, as back and left front, until front measures 51cm [20ins], and 47 sts remain.

Purl 1 row. Then knit 1 row.

Shape armhole With wrong side facing, cast off 4 sts. Purl to end of row. Knit 1 row. Then cast off 2sts, purl to end of row. 41 sts.

Join in pink, then light green, and work the pattern from Chart A, repeating the 16 pattern sts 2 times across, and working the

last 9 sts on k rows, and the first 9 sts on p rows as indicated.

Continue in this manner to row 31 of Chart.

Then work neck and shoulder as left front, but reversing all shapings.

Sleeves

With 3½mm needles and blue, cast on 66 sts. Knit 4 rows in garter st. Work pattern as follows:

Row 1: * k1, yo, k4, k2 tog, sl 1, k1, psso, k4, yo; rep from * to the last st, k1.

Row 2 (and all wrong side rows): Purl.

Repeat these 2 rows and work stripe sequence as follows:

2 rows blue/4 rows dusky green/2 rows light green/2 rows dusky green/1 row pink/3 rows dusky green.

Break off contrast yarns and with dusky green make tie-holes as follows:

* k1, yo, k2 tog; rep from * to end of row. Purl 1 row.

Continue straight in st.st until sleeve measures 35cm [13¾ins] from beg, with right side facing for next row.

Shape top Cast off 4 sts at beg of next 2 rows. Then cast off 2 sts at beg of next 2 rows. Work 4 rows straight.

Then decrease 1st at each end of next and every foll. 4th row until 48 sts remain.

Work 3 rows straight.

Then decrease 1 st at each end of next and every foll. 3rd row until 40 sts remain.

Work 1 row straight.

Then decrease 1 st at each end of next and every foll. alt. row until 30 sts remain.

Then decrease 1 st at each end of next and every foll. row until 20 sts remain.

Cast off.

Finishing

Press all pieces using a warm iron and damp cloth. Join back and fronts at shoulder seams and press. Sew up side and sleeve seams and press. Insert sleeves.

Front neck border With 3.5mm crochet hook, dusky green, and beginning at bottom

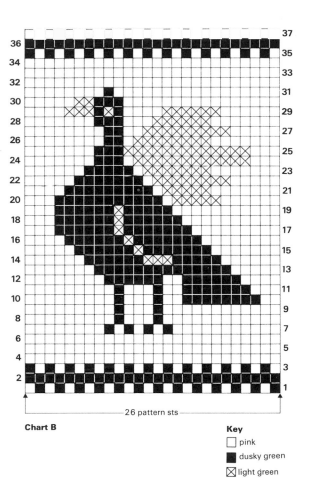

Chart B

Key

☐ pink
■ dusky green
☒ light green

— 26 pattern sts —

right front, work 3 rows of DC along right front, around neck, and along left front. Break off green yarn and work 1 row in blue. Fasten off. Press border lightly.

Make ties Using 2 strands each of pink, blue and light green, make 2 plaits, each 61cm [24ins] long. Knot each plait 5cm [2ins] from each end, to form a tassle. Thread plaits through tie-holes at wrists.

DRESS

Back

With 3½mm needles and pink, cast on 162 sts.

Excluding stripe sequence, work back as coat back, from ** to **.

Then cast off 2 sts at beg of next 2 rows.

Decrease 1 st at each end of next row. 78 sts.

Purl 1 row.

Join in contrast yarns and work the 37 rows of pattern from Chart B, repeating the 26 pattern sts 3 times across, and dividing the contrast yarns into separate balls for each bird motif.

Purl 1 row.

Shape shoulders Cast off 7 sts at beg of next 2 rows. Cast off 8 sts at beg of next 2 rows. Then cast off 9 sts at beg of next 2 rows. Cast off the remaining 30 sts (back neck).

Front
As back to row 33 of Chart B.

Shape neck/left shoulder With right side facing, pattern 28 sts. Leave the remaining sts on a spare needle.

Turn, and keeping continuity of pattern, work these 28 sts, decreasing 1 st at neck edge of next and every row until 24 sts remain.

Break off contrast, and purl 1 row.

Shape shoulder Cast off 7 sts, knit to the end of row. Purl 1 row. Cast off 8 sts, knit to the end of row. Purl 1 row. Then cast off the remaining 9 sts.

Shape neck/right shoulder With right side facing, cast off the next (front neck) 22 sts, pattern to the end of row.

Shape the neck/right shoulder as left but reversing all shapings.

Sleeves
With 3½mm needles and pink, cast on 66 sts.

Excluding stripe sequence, work the sleeve as coat sleeve (14 rows chevron pattern and tie-hole row).

Work in st.st until sleeve measures 7cm [2¾ins] from beg, with right side facing for next row.

Shape top as coat sleeve. Cast off.

Collar
With 3½mm needles and pink, cast on 118 sts. Knit 4 rows in garter st.

Work 8 rows in chevron pattern, as sleeves. Then work 3 rows in st.st.

Make tie-holes as follows:

* k1, yo, k2 tog; rep from * to the last st, k1.

Purl 1 row. Then work 8 rows in k1, p1 rib. Cast off evenly.

Finishing
Omitting ribbing, press all pieces using a warm iron and damp cloth.

Join back and front at shoulder seams, leaving an opening of 3cm [1in] at neck edge of left shoulder. Press seams.

Sew up side and sleeve seams and press. Insert sleeves.

Attach cast off edge of collar around neck edge, beginning at left front shoulder and ending at left back shoulder.

Neck opening With 3.5mm crochet hook and pin, work 2 rows of DC around collar/neck opening.

Ties Using 2 strands each of blue, dusky green and light green, make 2 plaits each 61cm [24ins] long, for sleeves, and 1 plait 76cm [30ins] long, for collar. Knot each plait 5cm [2ins] from each end to form tassels.

Thread the appropriate plaits through tie-holes on sleeves and collar.

HAT

With 3½mm needles and blue, cast on 139 sts. Knit 4 rows in garter st.

Work pattern as coat back, working stripe sequence as follows:

8 rows dusky green/4 rows light green/4 rows dusky green/2 rows pink.

Break off contrast yarns and with dusky green work 2 more rows.

Then decrease as 1st decrease on coat back.

Continue straight for 6 rows.

Then decrease as 2nd decrease on coat back.

Continue straight for 4 rows.

Then decrease as 3rd decrease on coat back.

Work 1 row.

Then decrease in the same manner on the next and every foll. alt. row until 43 sts remain. Purl 1 row.

Next row: k2 tog; rep to the last st, k1. 22 sts.

Finishing

Break off yarn approx. 20cm [8ins] from the last st. Thread this into a darning needle and pass through the remaining sts several times, pulling tightly to form the crown. Fasten off. Press hat.

Sew up back seam and press.

Baltic
Man's slip-over

This slip-over uses another typically Finnish pattern, taken from a mitten knitted around 1930. The pattern, however, is considerably older than that, and is still popular today. The mitten combines a number of different elements, including free-flowing waves and three-leaf clovers, knitted in solid shades on a neutral background. Baltic uses only the wave-like patterns, in similarly strong colours.

(See colour photograph opposite page 33.)

Materials
4 (5, 5, 5, 6) 50g balls of Standard 4-Ply yarn in MS.
1 50g ball of Standard 4-Ply yarn in 1st C.
1 (1, 1, 2, 2) 50g balls of Standard 4-Ply yarn in 2nd C.
1 pair each 2¾mm and 3¼mm needles.

The yarn used in this garment is Sirdar 'Majestic' 4-Ply in Banana, with Turf Brown and Carmine.

Measurements
To fit chest: 91 (97, 102, 107, 112)cm [36 (38, 40, 42, 44)ins].
Length from top of shoulder: 59 (61, 62, 64, 66)cm [23¼ (24, 24½, 25¼, 26)ins].

Tension
14 sts and 17 rows to 5cm [2ins] working in pattern and using 3¼mm needles.

Back
* With 2¾mm needles and MS cast on 114 (122, 128, 134, 142) sts.
 k1, p1 rib for 8cm [3ins].
 Next row: Rib 2 (6, 4, 2, 6), (m1, rib 5) 22 (22, 24, 26, 26) times, m1, rib 2 (6, 4, 2, 6). 137 (145, 153, 161, 169) sts.

Change to 3¼mm needles, and joining in and breaking off C colours as required, work the pattern from Chart, repeating the 16 pattern sts 8 (9, 9, 10, 10) times across, and working the first 4/0/4/0/4 sts and the last 5/1/5/1/5 sts on k rows, and the first 5/1/5/1/5 sts and the last 4/0/4/0/4 sts on p rows as indicated. Continue in this manner until back measures 36 (37, 37, 37, 38)cm [14 (14½, 14½, 14½, 15)ins] from beg, with right side of work facing for next row.**

Shape armholes Keeping continuity of pattern, cast off 6 sts at beg of next 2 rows. Decrease 1 st at each end of the next 3 (3, 3, 5, 5) rows. Work 1 row. Then decrease 1 st at each end of next and every foll. alt. row until 109 (113, 117, 121, 127) sts remain. Continue straight until back measures 59 (61, 62, 64, 66)cm [23¼ (24, 24½, 25¼, 26)ins], with right side facing for next row.

Shape shoulders Cast off 10 (10, 11, 11, 12) sts at beg of next 2 rows. Cast off 10 (11, 11, 11, 12) sts at beg of next 2 rows. Then cast off 11 (11, 11, 12, 12) sts at beg of next 2 rows. Leave remaining 47 (49, 51, 53, 55) sts on a spare needle.

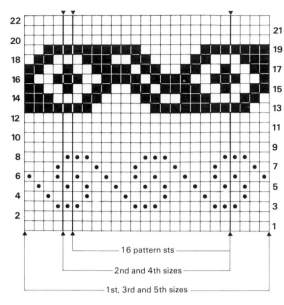

```
22
20
18
16
14
12
10
 8
 6
 4
 2
                                                    21
                                                    19
                                                    17
                                                    15
                                                    13
                                                    11
                                                     9
                                                     7
                                                     5
                                                     3
                                                     1
```

├─── 16 pattern sts ───┤

├──── 2nd and 4th sizes ────┤

├───── 1st, 3rd and 5th sizes ─────┤

Key
☐ MS
⊡ 1st C
■ 2nd C

Front
As back from * to **.

Shape armholes and divide for neck
Keeping continuity of pattern, cast off 6 sts,
pattern 60 (64, 68, 72, 76) sts, k2 tog. Turn.
Leave remaining sts on a spare needle.
Continue on these 61 (65, 69, 73, 77) sts for
first side and work 1 row.

Decrease 1 st at armhole edge of next 3 (3,
3, 5, 5) rows, then on every foll. alt. row. *At
the same time* decrease 1 st at neck edge on
next and every foll. alt. row until 46 (46, 46,
47, 49) sts remain.

Decrease at neck edge *only*, on every 3rd
row from previous decrease until 31 (32, 33,
34, 36) sts remain.

Work straight in pattern until front
matches back to start of shoulder shaping,
ending with right side facing for next row.

Shape shoulder Cast off 10 (10, 11, 11, 12)
sts at beg of next row. Work 1 row. Cast off
10 (11, 11, 11, 12) sts at beg of next row.
Work 1 row. Cast off remaining 11 (11, 11,
12, 12) sts.

With right side of work facing, slip centre
st onto a safety pin, rejoin yarn to remaining
sts, k2 tog, pattern to end. Complete to
correspond with first side, reversing all
shapings.

Finishing
Omitting ribbing, press all parts using a
warm iron and damp cloth. Join right
shoulder seam. Press.

Neck border With right side of work
facing, 2¾mm needles and MS, knit up 74
(78, 82, 84, 88) sts down left side of neck,
knit centre st from safety pin and mark this
st with a coloured thread, knit up 74 (78,
82, 84, 88) sts up right side of neck, knit the 47
(49, 51, 53, 55) sts from back of neck,
decreasing 1 st at centre back. 195 (205,
215, 221, 231) sts.

Work in rib as follows:
Row 1: * p1, k1; rep from * to within 2
sts of marked st, p2 tog, p1, p2 tog tbl, **
k1, p1; rep from ** to end.

Row 2: k1, * p1, k1; rep from * to within
2 sts of marked st, p2 tog, k1, p2 tog tbl, k1,
** p1, k1; rep from ** to end.

Repeat these 2 rows 4 times more. Cast off
evenly in rib, decreasing 1 st at each side of
marked st as before. Join left shoulder seam
and neck border. Press shoulder seam.

Armhole borders With right side of work
facing, 2¾mm needles and MS, knit up 140
(144, 150, 156, 162)sts all along each
armhole. Work 10 rows k1, p1 rib. Cast off
evenly in rib. Join side seams and armhole
borders. Press seams.

Karelia (page 109).

96

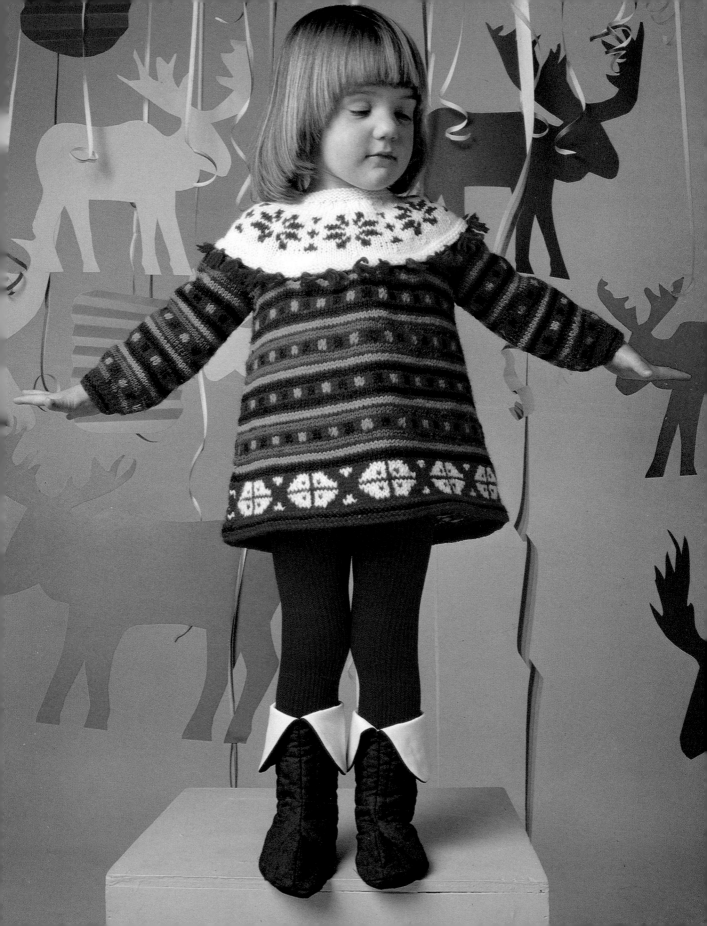

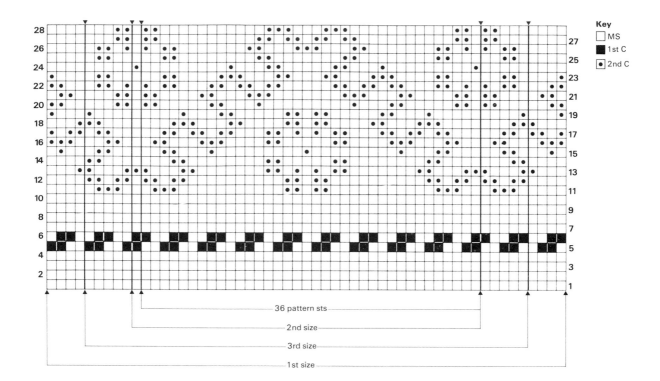

Place the next 41 (49, 55) sts (back neck) on a length of yarn. Pick up the remaining 28 (30, 31) sts from spare needle and work the left shoulder as right, but reversing all shapings.

Front

As back from * to **.

Pattern straight until front measures 48 (53, 57)cm [19 (21, 22½)ins], with right side facing for next row.

Shape neck Pattern 35 (37, 38) sts. Leave remaining sts on a spare needle. Turn and work these sts (left shoulder), decreasing 1 st at neck edge of next 7 rows. Then decrease 1 st at neck edge of every foll. alt. row until 21 (23, 24) sts remain. Cast off. Place the next 27 (35, 41) sts (front neck), on a length of yarn. Pick up the remaining 35 (37, 38) sts of right shoulder and work as left, but reversing all shapings.

Finishing

Omitting ribbing, press both pieces using a warm iron and damp cloth. Sew back left shoulder to front left shoulder. Press seam.

Collar With right side of work facing, 2¾mm needles and MS, knit up 7 sts along right neck edge, 55 (63, 69) sts across back neck, 7 sts along left neck edge, 21 sts along left front neck edge, 27 (35, 41) across front neck, 21 sts along right front neck edge, 138 (154, 166) sts. k1, p1 rib for 10 rows. Change to 3¼mm needles and rib until collar measures 10cm [4ins]. Cast off evenly in rib. Sew up right shoulder and collar seam. Press shoulder seam.

Armhole bands With right side of work facing, 2¾mm needles and MS, knit up 116 (128, 140) sts along armhole edges.

k1, p1 rib for 10 rows. Cast off evenly in rib. Sew up side seams and armhole bands. Press seams.

Ruska
Man's slip-over

Ruska is literally the russet season, meaning autumn in Finnish Lapland, which seems an apt name for this slip-over in autumnal shades of russet and beige. The mitten that inspired it demonstrates another facet of the mixed Finnish style, for it is very Norwegian in nature, with an all-over geometric pattern in dark brown and cream. It is small-scale and therefore not too difficult to work.

Materials
3 (3, 3, 4, 4) 50g balls of Standard DK yarn in MS.
2 (2, 3, 3, 3) 50g balls of Standard DK yarn in C.
1 pair each 3¼mm and 4mm needles

Measurements
To fit chest: 91 (97, 102, 107, 112)cm [36 (38, 40, 42, 44)ins]
Length from top of shoulder: 59 (61, 62, 64, 66)cm [23¼ (24, 24½, 25¼, 26)ins]

Tension
11½ sts and 15 rows to 5cm [2ins] measured over st.st using 4mm needles.

Back
* With 3¼mm needles and MS, cast on 103 (109, 115, 121, 128) sts.
 k1, p1 rib for 8 (8, 8, 10, 10)cm [3, (3, 3, 4, 4)ins], sts on right side rows of first 4 sizes having a k at each end.
 Next row: Rib 2 (5, 2, 5, 4) [m1, rib 11 (11, 10, 10, 10)] 9 (9, 11, 11, 12) times, m1, rib 2 (5, 3, 6, 4). 113 (119, 127, 133, 141) sts.
 Change to 4mm needles and joining in C, work the 10 rows of pattern from Chart,

repeating the 14 pattern sts 8 (8, 9, 9, 10) times across, and working the first 0/3/0/3/0 sts and the last 1/4/1/4/1 sts on k rows, and the first 1/4/1/4/1 and the last 0/3/0/3/0 sts on p rows as indicated.
 Continue in this manner until back measures 36 (37, 37, 38, 38)cm [14 (14½, 14½, 15, 15)ins], ending with right side facing for next row. **

Shape armholes Keeping continuity of pattern, cast off 4 sts at beg of next 2 rows. Decrease 1 st at each end of next 8 (8, 10, 10, 11) rows. Work 1 row. Then decrease 1 st at each end of next and every foll. alt. row until 83 (87, 93, 97, 103) sts remain. Continue straight until back measures 59 (61, 62, 64, 66)cm [23¼ (24, 24½, 25¼, 26)ins].

Shape shoulders Keeping continuity of pattern, cast off 8 (8, 9, 9, 10) sts at beg of next 4 rows. Cast off 8 (9, 9, 10, 10) sts at beg of next 2 rows. Leave remaining 35 (37, 39, 41, 43) sts on a spare needle.

Front
As back from * to **.

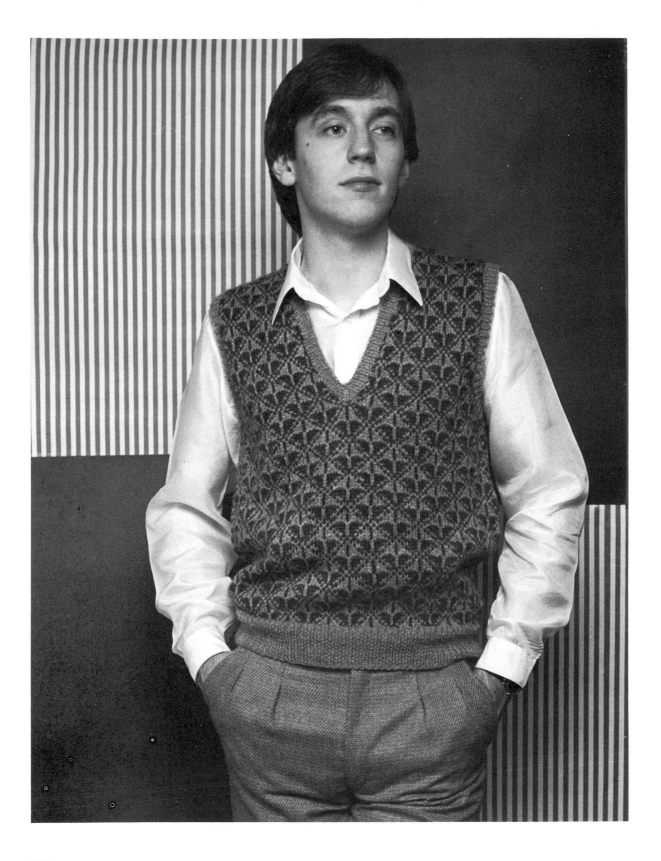

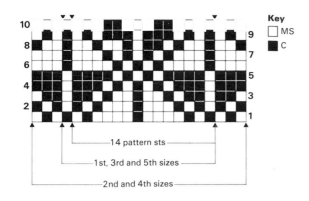

Key
☐ MS
■ C

14 pattern sts

1st, 3rd and 5th sizes

2nd and 4th sizes

Shape armholes and divide for neck Next row: Cast off 4 sts, pattern 50 (53, 57, 60, 64) sts (including st on needle after cast off), k2 tog. Turn, and leave remaining 57 (60, 64, 67, 71) sts on a spare needle.

Continue on these 51 (54, 58, 61, 65) sts, decreasing 1 st at armhole edge of next 8 (8, 10, 10, 11) rows, then on every foll. alt. row, *at the same time* decrease 1 st at neck edge of every 3rd row from first decrease, until 36 (37, 40, 41, 43) sts remain.

Decrease 1 st at neck edge *only*, on every 3rd row from previous decrease, until 24 (25, 27, 28, 30) sts remain. Continue straight until front corresponds with back at shoulder edge, ending with right side facing for next row.

Shape shoulder Cast off 8 (8, 9, 9, 10) sts at beg of next and foll. alt. row. Work 1 row. Cast off remaining 8 (9, 9, 10, 10) sts.

With right side facing, slip centre st onto a safety pin, rejoin yarns to right side, k2 tog, pattern to end of row. Complete to correspond with right side, reversing all shapings.

Finishing
Omitting ribbing, press pieces using a warm iron and damp cloth. Join right shoulder seam.

Neck border With right side of work facing, $3\frac{1}{4}$mm needles and MS, knit up 60 (64, 66, 68, 70) sts down left side of neck, knit centre st from safety pin (mark this st with a coloured thread), knit up 61 (63, 65, 67, 69) sts up right side of neck, knit 35 (37, 39, 41, 43) sts from back of neck. 157 (165, 171, 177, 183) sts.

Work rib as follows:
Row 1: * p1, k1; rep from * to within 2 sts of marked st, p2 tog, p1, p2 tog tbl, ** k1, p1; rep from ** to end.
Row 2: k1, * p1, k1; rep from * to within 2 sts of marked st, p2 tog, k1, p2 tog tbl, k1, ** p1, k1; rep from ** to end.

Repeat these 2 rows 3 times more. Cast off evenly in rib, decreasing 1 st at each side of marked st as before. Join left shoulder seam and neck border.

Armhole borders With right side of work facing, $3\frac{1}{4}$mm needles and MS, knit up 108 (112, 118, 124, 130) sts. k1, p1 rib for 6 rows. Cast off evenly in rib. Join up side seam and armhole border. Press seams.

Kaltimo

Man's sweater

So far, all the patterns in this section have come from unspecified parts of Finland, but it is reasonable to suppose they originated in the western part of the country. Nearer the border with the Soviet Union the patterns start to gain certain quite new characteristics, as the East-West balance is tipped steadily eastwards.

The eastern border of Finland has tended throughout history to be somewhat unstable, and after World War II Finland lost almost 10 per cent of its territory to the Soviet Union. This makes it difficult to decide exactly where Finnish knitting ends and Russian knitting begins, especially as certain provinces, such as Karelia, are now split by the border.

Kaltimo is a town in Finnish Karelia, and it is from there that I took the pattern on this raglan-sleeved sweater for men. The pattern, which is taken from a mitten, is one that begins to show a more pronounced eastern influence. Such patterns are geometric, but the geometry is more intricate than usual, and its designs are interlinked in a very subtle way. You can see this on the border which decorates the hem of the sweater. The body is worked in much simpler zig-zag stripes, taken from the main part of the mitten.

The original colours of the mitten were very soft and pale, and I decided to keep to them, using a lightweight mohair yarn to accentuate the lightness and softness of the pattern.

(See colour photograph opposite page 97.)

Materials
5 (6, 6, 6) 50g balls of 4-ply mohair yarn in light grey.
1 50g ball each in 4 contrast colours – brown/gold/beige/green.
1 pair each 3mm and 3¾mm needles.

Measurements
To fit chest: 91 (97, 102, 107)cm [36 (38, 40, 42)ins].
Length from top of shoulder: 64 (67, 70, 73)cm [25¼ (26½, 27½, 28½)ins].
Sleeve seam: 43 (45, 46, 48)cm [17 (17½, 18, 18½)ins].

Tension
13 sts and 15 rows to 5cm [2ins] measured over st.st using 3¾mm needles.

Back
** With 3mm needles and light grey, cast on 106 (114, 120, 130) sts. k1, p1 rib for 8cm [3ins].

Next row: Rib 4 (1, 4, 2) [m1, rib 7 (8, 8, 9)] 14 times, m1, rib 4 (1, 4, 2). 121 (129, 135, 145) sts.

Change to 3¾mm needles, and joining in and breaking off colours as required work the 26 rows of pattern from Chart A, repeating the 24 pattern sts 5 (5, 5, 6) times across, and working the first 0/4/7/0 sts and the last 1/5/8/1 sts on k rows, and the first 1/5/8/1 sts and the last 0/4/7/0 sts on p rows as indicated. Then joining in and breaking off contrast colours as required, work the 40 rows of pattern from Chart B, repeating the 4 pattern sts 30 (32, 33, 36)

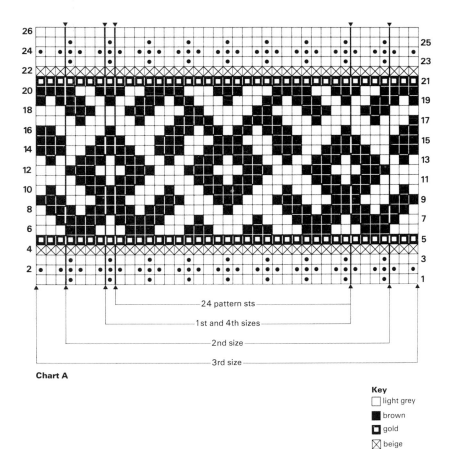

Chart A

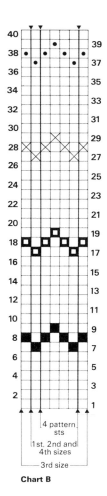

Chart B

Key
- ☐ light grey
- ■ brown
- ▣ gold
- ⊠ beige
- ⊙ green

times across and working the first 0/0/1/0 sts and the last 1/1/2/1 sts on k rows, and the first 1/1/2/1 sts and the last 0/0/1/0 sts on p rows as indicated.

Continue in this manner, repeating these 40 rows until back measures 40 (42, 43, 45)cm [$15\frac{3}{4}$ ($16\frac{1}{2}$, 17, $17\frac{3}{4}$)ins], with right side facing for next row.

Shape raglan Keeping continuity of pattern, cast off 4 sts at beg of the next 2 rows.

Next row: k1, k2 tog, knit to the last 3 sts, ssk, k1.

Next row: purl.**

Repeat these 2 rows until 43 (47, 49, 53) sts remain. Leave these sts on a spare needle.

Front
As back from ** to **.

Repeat these 2 rows until 63 (65, 69, 73) sts remain. Purl 1 row.

Shape neck Keeping continuity of pattern, k1, k2 tog, k17. Leave the remaining sts on a spare needle. Turn and purl 1 row.

Left neck Row 1: k1, k2 tog, knit to the last 2 sts, k2 tog. Row 2: Purl.

Repeat these 2 rows until 3 sts remain.
Next row: sl 1, k2 tog, psso. Fasten off.

Front/right neck With right side facing, place the next (front neck) 23 (25, 29, 33) sts on to a length of yarn.

Rejoin yarn to the remaining sts, knit to the last 3 sts, ssk, k1. Purl 1 row. Then work right neck as left, reversing shapings.

Sleeves

With 3mm needles and light grey, cast on 52 (56, 58, 64) sts.

k1, p1 rib for 8cm [3ins].

Next row: Rib 2 (4, 1, 4) [m1, rib 6 (6, 7, 7)] 8 times, m1, rib 2 (4, 1, 4). 61 (65, 67, 73) sts.

Change to $3\frac{3}{4}$mm needles and joining in and breaking off contrast colours as required, work the 40 rows of pattern from Chart B, repeating the 4 pattern sts 15 (16, 16, 18) times across, and working the edge sts as back and front, as indicated on chart.

Increase 1 st at each end of the 6th pattern row, and every foll. 5th row until there are 91 (95, 99, 105) sts, working increased sts into pattern.

Then continue straight until colour stripes and pattern row correspond with back and front, and sleeve measures approx. 43 (45, 46, 48)cm [17 ($17\frac{1}{2}$, 18, $18\frac{1}{2}$)ins] from beg, with right side facing for next row.

(NB. It is important to cast off for raglan on the same pattern row as back and front, in order for the colour stripes to match at raglan seams.)

Shape raglan Keeping continuity of pattern, cast off 4 sts at beg of the next 2 rows.

Next row: k1, k2 tog, knit to the last 3 sts, ssk, k1.

Next row: Purl.

Repeat these 2 rows until 21 (19, 21, 21) sts remain, and pattern row corresponds with back. Place these sts on a length of yarn.

Finishing

Omitting ribbing, press all pieces using a warm iron and damp cloth. Join back and front to sleeves at raglan seams, matching stripes and leaving the back/right sleeve seam open.

Neckband With right side facing, 3mm needles, and light grey, pick up and knit the 43 (47, 49, 53) sts from back, decreasing 4 sts evenly across, then pick up and knit the 21 (19, 21, 21) sts from left sleeve, knit up 16 sts down left side, pick up and knit the 23 (25, 29, 33) sts from front neck, decreasing 4 sts evenly across, then knit up 16 sts up right side, pick up and knit the 21 (19, 21, 21) sts from right sleeve. 132 (134, 144, 152) sts.

k1, p1 rib for 8cm [3ins]. Cast off evenly.

Sew up the remaining raglan seam and neckband. Fold neckband in half to the inside and catchstitch neatly in position.

Press raglan seams. Sew up side and sleeve seams and press. Brush the garment lightly using a teazle brush.

Kymi
Woman's cardigan

The province of Kymi lies not only on the Soviet border, but also on that arm of the Baltic Sea known as the Gulf of Finland. Leningrad is less than 100 miles away. Gloves from these border areas are frequently knitted plain – apart from a wrist decoration, which has all the same characteristics as the border on the mitten I mentioned in the previous pattern, Kaltimo. One particular glove was knitted in plain beige, but there in mauve on the wrist was a border that showed all those interlinked, geometric features. I repeated the border to form an all-over pattern on this cardigan, the body of which is knitted in one piece. In order to retain a horizontal effect, the background is split into two shades of pink, one deep and the other somewhat lighter. I have also used the typical striped chevrons to decorate the waist, cuffs and collar, while the ties and tassles provide the extravagant flourish that is so common in Finnish knitting.

Materials
5 (5, 6, 6) 50g balls of Standard DK yarn in MS.
3 (4, 4, 5) 50g balls of Standard DK yarn in 1st C.
3 (4, 4, 5) 50g balls of Standard DK yarn in 2nd C.
1 pair 4mm needles.
7 buttons.

The yarn used in this garment is Hayfield 'Brig' DK in Petrol Blue, Dusky Pink, and Strawberry.

Measurements
To fit bust: 81 (86, 91, 97)cm [32 (34, 36, 38)ins].
Length from top of shoulder: 51 (53, 55, 57)cm [20 (21, 21½, 22½)ins].
Sleeve seam: 43 (43, 44, 44)cm [17 (17, 17½, 17½)ins].

Tension
11½ sts and 12 rows to 5cm [2ins] measured over st.st using 4mm needles.

Body
With 4mm needles and MS, cast on 193 (205, 217, 229) sts. Knit 2 rows garter st.
Now work chevron pattern as follows:
 Row 1: * k1, yo, k4, sl 1, k2 tog, psso, k4, yo; rep from * to last st, k1.
 Row 2: Purl.
 These 2 rows form pattern.
Now work stripe sequence as follows:
 4 rows 1st C, 4 rows 2nd C, 2 rows MS, 2 rows 1st C, 2 rows 2nd C.
 Working in MS, make eyelets as follows:
 * k1, yo, k2 tog; rep from * to last st, k1. 193, (205, 217, 229) sts. Purl 1 row.
 Joining in and breaking off shades as required, work the 30 rows of pattern from

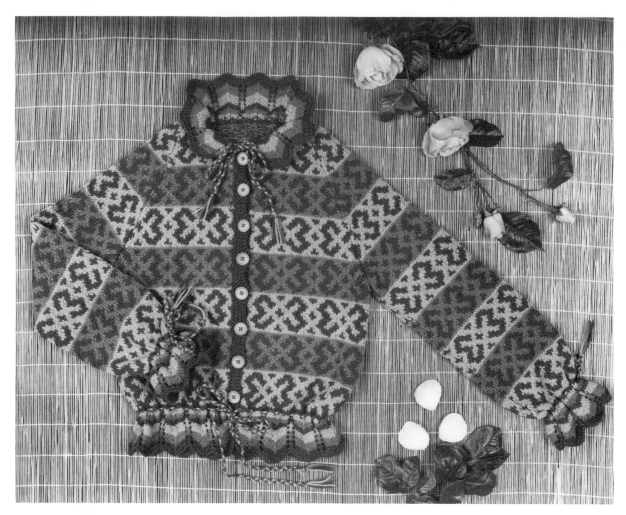

Chart, repeating the 24 pattern sts 8 (8, 9, 9) times across, and working the first 0/6/0/6 sts and the last 1/7/1/7 sts on k rows, and the first 1/7/1/7 sts and the last 0/6/0/6 sts on p rows as indicated. Continue in this manner until body measures 22 (23, 23, 24)cm [8½, (9, 9, 9½)ins] from beg of Chart pattern, with right side facing for next row.

Divide for armholes Pattern 46 (49, 52, 55) sts. Leave remaining sts on a spare needle. Turn and shape the right front as follows:

 All wrong side rows: Pattern straight.

 All right side rows: Pattern to last 3 sts (armhole edge), ssk, k1.

Continue decreasing in this manner until 25 (26, 28, 30) sts remain, and front

measures 40 (42, 43, 45)cm [15¾ (16½, 17, 17¾)ins] from beg of Chart pattern, with right side of work facing for next row.

Shape neck Cast off 7 (8, 8, 8) sts at beg of next row. Work to last 3 sts, ssk, k1. Decrease 1 st at each end of every row until 3 sts remain. Sl 1, k2 tog, psso, to cast off.

Shape back
Pick up and cast off the next 4 sts from spare needle (right armhole). Keeping continuity of pattern, pick up and pattern the next 93 (99, 105, 111) sts. Leave remaining sts on the spare needle. Turn, and working these sts, shape back as follows:

 All wrong side rows: Pattern straight.

106

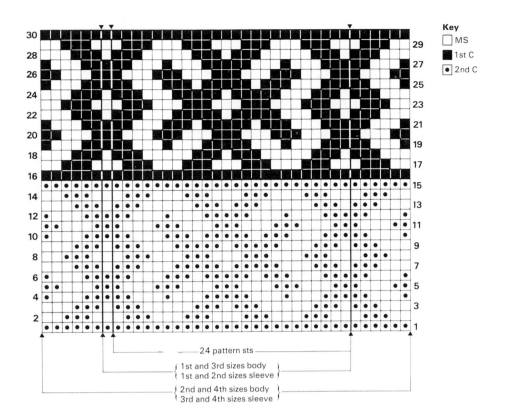

Key
☐ MS
■ 1st C
▣ 2nd C

24 pattern sts

1st and 3rd sizes body
1st and 2nd sizes sleeve

2nd and 4th sizes body
3rd and 4th sizes sleeve

All right side rows: k1, k2 tog, k to the last 3 sts, ssk, k1.

Continue decreasing in this manner until 51 (53, 57, 61) sts remain. Decrease 1 st at each end of every row until 31 (33, 35, 37) sts remain. Cast off evenly.

Shape left front
Pick up and cast off the next 4 sts from spare needle (left armhole). Keeping continuity of pattern, pick up and pattern the remaining 46 (49, 52, 55) sts of left front, as right front but reversing all shapings.

Sleeves
With 4mm needles and MS, cast on 73 (73, 85, 85) sts. Work chevron pattern, stripe sequence and eyelet row, as body.

Joining in and breaking off shades as required, work the 30 rows of pattern from Chart, repeating the 24 pattern sts 3 times across, and working the first 0/0/6/6 sts and

the last 1/1/7/7 sts on k rows, and the first 1/1/7/7 sts and the last 0/0/6/6 sts on p rows as indicated. Continue in this manner until sleeve measures approx. 43 (43, 44, 44)cm [17 (17, 17½, 17½)ins] from beg, with right side of work facing for next row, and pattern row corresponding with the 4 sts cast off for armhole on body.

Shape armhole Cast off 2 sts at beg of next 2 rows. Shape sleeve as back until 21 (21, 29, 29) sts remain. Decrease 1 st at each end of every row until 5 sts remain. Cast off.

Collar
With 4mm needles and MS, cast on 109 (109, 121, 121) sts. Work chevron pattern, stripe sequence and eyelet row as body. Work 2 rows st.st in MS. Cast off evenly.

Finishing
Press all pieces using a warm iron and damp cloth. Sew up sleeve seams. Insert sleeves.

Mark centre back of neck and centre back of collar. Pin, and then sew wrong side of collar to right side of neck evenly, matching centre marks.

Left button band With 4mm needles, MS and right side of work facing, knit up 74 (78, 80, 84) sts evenly from neck to eyelet row. Knit 5 rows in garter st. Cast off evenly.

Right buttonhole band
With 4mm needles, MS and right side of work facing, knit up 74 (78, 80, 84) sts from eyelet row to neck. Knit 3 rows in garter st.
 Next row: Make buttonholes: k1 (3, 4, 3)
* cast off 2, k8 (8, 8, 9) (including st on needle after cast off); rep from * to last 3 (5, 6, 4) sts, cast off 2, k1 (3, 4, 2).
 Next row: k1 (3, 4, 2) * cast on 2, k8 (8, 8, 9); rep from * to last 1 (3, 4, 3) sts, cast on 2, k1 (3, 4, 3).
 Knit 1 row. Cast off evenly. Press both bands very lightly.

Make ties Using 2 strands of yarn in each of the 3 shades, cut 2 sets 66cm [26ins] long, for wrists. Cut 1 set 106cm [42ins] long, for neck. Cut 1 set 175cm [70ins] long, for waist. Plait each set of strands and knot each end 3cm [1in] from end to form a tassle. Thread the appropriate ties through the eyelets in neck, wrists and waist. Sew on buttons.

Karelia
Child's dress

Another example of a decoration with a flourish is found in the tassled gloves of Karelia. The tassles are obviously impractical, which indicates that the gloves were worn only for festive occasions. The design includes a wide variety of geometric features, including simple stripes, squares and bands of eight-petal roses. The colours are equally varied, making it a perfect example of the richness of Finnish knitting. There is red, green, gold, navy and white. Such gloves must have been very popular in Karelia, as many examples remain today.

Richness and festivity are the qualities that I set out to capture in this little girl's dress, based on the Karelian glove. All the deep, warm colours are used, and all the different small designs, including the eight-petal roses on the circular yoke, and cerise-coloured tassles.

(See colour photograph opposite page 96.)

Materials
4 (6) 25g balls of Standard DK yarn in Cerise.
2 (3) 25g balls of Standard DK yarn in White.
2 (2) 25g balls of Standard DK yarn in Navy.
2 (2) 25g balls of Standard DK yarn in Gold.
1 (2) 25g balls of Standard DK yarn in Green.
1 pair 4mm needles.
5 white buttons.

Measurements
Age 2 to 3 (4 to 5) years
To fit chest: 56 (61)cm [22 (24)ins]
Length from top of shoulder: 41 (52)cm [$16\frac{1}{4}$ ($20\frac{1}{2}$ins]
Sleeve seam: 23 (27)cm [9 ($10\frac{1}{2}$)ins]

Tension
$11\frac{1}{2}$ sts and 14 rows to 5cm [2ins] measured over st.st using 4mm needles.

Back and front (2 pieces alike)
With 4mm needles and cerise, cast on 91 (103) sts.
Knit in garter st as follows:
2 rows cerise/2 rows navy/2 rows cerise.
Break off navy. Join in white and work the 12 rows of pattern from Chart A, repeating the 18 pattern sts 5 times across, and working the first 0/6 sts and the last 1/7 sts on k rows, and the first 1/7 sts and the last 0/6 sts on p rows as indicated. Decrease 1 st at each end of the 12th pattern row. 89 (101) sts. Break off white yarn.
Then joining in and breaking off colours as required, work the 24 rows of pattern from Chart B, repeating the 8 pattern sts 11 (12) times across, and working the first 0/2 sts and the last 1/3 sts on k rows, and the first 1/3 sts and the last 0/2 sts on p rows as indicated.
Keeping continuity of pattern, decrease 1 st at each end of the 10th pattern row and

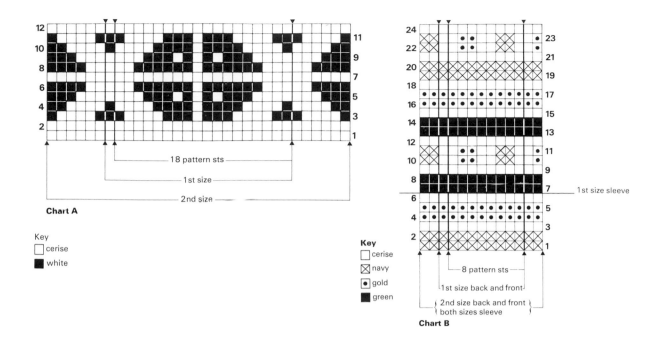

Chart A

Key
☐ cerise
■ white

Key
☐ cerise
⊠ navy
• gold
■ green

Chart B

every foll. 10th (15th) row until 81 (93) sts
**remain. Then continue straight until piece
measures 27 (38)cm [10¾ (15)ins] from beg,
with right side facing for next row.**

Shape armholes Keeping continuity of
pattern, cast off 3 sts at beg of next 2 rows.

Gather front and shape sides as follows:

Next row: k2 tog, pattern 11 (14), k2 tog,
* sl 1, k2 tog, psso; rep from * to the last 15
(18) sts, k2 tog, pattern 11 (14), k2 tog.

Next row: Pattern 12 (15) and leave these
sts on a spare needle, cast off the next 17
(19) sts *very loosely*, pattern 12 (15).

Keeping continuity of pattern, work these
12 (15) sts of left side, decreasing 1 st at each
end of the next and every foll. alt. row until
2 (3) sts remain.

Next row: 1st size: k2 tog. Fasten off.

Next row: 2nd size: Sl 1, k2 tog, psso.
Fasten off.

With right side facing and keeping
continuity of pattern, pick up the 12 (15) sts
of right side and work as left.

Sleeves

With 4mm needles and cerise, cast on 27
(31) sts. Knit in garter st as follows:

4 rows cerise/2 rows navy/6 rows cerise.

Break off navy, and with cerise increase as
follows:

k1, * m1, k1; rep from * to end of row.
53 (61) sts.

Joining in and breaking off colours as
required, work the pattern from Chart B,
beginning at row 7 (1) as indicated. Repeat
the 8 pattern sts 6 (7) times across, and work
the first 2 sts and the last 3 sts on k rows,
and the first 3 sts and the last 2 sts on p rows
as indicated.

Continue in this manner until pattern row
corresponds with back and front at armhole,
and sleeve measures approx. 23 (27)cm
[9 (10½)ins], with right side facing for next row.

Shape top Keeping continuity of pattern,
cast off 3 sts at beg of next 2 rows. Then
decrease 1 st at each end of the next and
every foll. alt. row until 39 (45) sts remain.
Work 1 row.

Next row: k1 * k2 tog; rep from * to end
of row. 20 (23) sts.

Then with wrong side facing, cast off
loosely.

Yoke

With 4mm needles and white, cast on 144

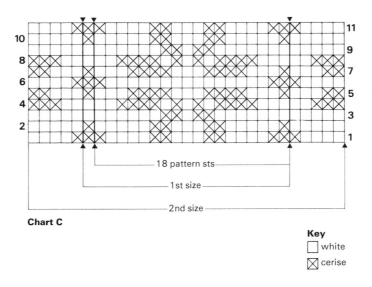

Chart C

Key
☐ white
☒ cerise

(154) sts. Knit 4 rows in garter st. Then work 4 (8) rows in st.st.

Next row: k4 (1), [k2 tog, k6 (7)] 17 times, k4 (0). 127 (137) sts. Purl 1 row.

Join in cerise and work the 11 rows of pattern from Chart C, repeating the 18 pattern sts 7 times across, and working the first 0/5 sts and the last 1/6 sts on k rows, and the first 1/6 sts and the last 0/5 sts on p rows as indicated.

Break off cerise and purl 1 row.

Next row: k4 (1), [k2 tog, k5 (6)] 17 times, k4 (0). 110 (120) sts.

Work 3 (5) rows in st.st.

Next row: k1 (2), * k2 tog, k2; rep from * to the last 1 (2) sts, k1 (2). 83 (91) sts.

Work 1 (3) rows in st.st.

Next row: k7 (9), * k2 tog; rep from * to the last 8 (10) sts, k8 (10). 49 (55) sts.

Purl 1 row. Then knit 5 rows in garter st. With wrong side facing, cast off evenly.

Button band With right side of yoke facing, 4mm needles and white, knit up 26 (30) sts along left end of yoke. Knit 4 rows in garter st. Cast off evenly.

Buttonhole band With right side of yoke facing, 4mm needles and white, knit up 26 (30) sts along right end of yoke. Knit 2 rows.

Next row: k1 (3) * yo, k2 tog, k3; rep from * to the last 0 (2) sts, k0 (2).

Knit 1 row. Then cast off evenly.

Finishing
Omitting garter st, press all pieces using a warm iron and damp cloth. Join sleeves to back and front at armhole seams. Press seams.

Fold yoke in half and mark centre front. Pin the centre front of yoke to the centre front of dress, leaving the garter st edge of yoke to overlap the dress. Pin the lower end of button band to the centre back of dress, overlapping the garter st edge. Then pin the lower end of buttonhole band on top of button band, to form back yoke opening. Pin the rest of the yoke around the dress, leaving the garter st edge of yoke over-lapping all the way round.

Turn the dress to the inside and with white yarn oversew the yoke neatly to the dress, easing evenly all round. Press the seam gently. Sew up side and sleeve seams and press.

Tassles To make each tassle, cut 3 strands of cerise yarn, each 8cm [3ins] long. Attach the tassles to cast on edge of yoke at 2½cm [1in] intervals. Sew buttons onto button band to correspond with buttonholes.

111

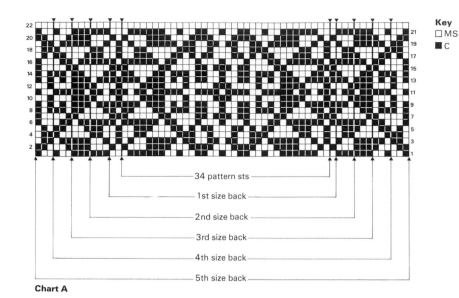

Key
□ MS
■ C

34 pattern sts
1st size back
2nd size back
3rd size back
4th size back
5th size back

Chart A

8cm [3ins] with wrong side of work facing for next row.

Next row: Rib 3 (7, 2, 5, 1) [m1, rib 6 (5, 7, 6, 8)] 14 (16, 14, 16, 14) times, m1, rib 3 (7, 2, 5, 1). 105 (111, 117, 123, 129) sts.

Change to 4mm needles and joining in C, work the 22 rows of pattern from Chart A, repeating the 34 pattern sts 3 times across, and working the first 1/4/7/10/13 sts and the last 2/5/8/11/14 sts on k rows, and the first 2/5/8/11/14 sts and the last 1/4/7/10/13 sts on p rows as indicated. Continue in this manner until back measures 43 (43, 44, 44, 44)cm [17 (17, 17½, 17½, 17½)ins].

Shape armholes Keeping continuity of pattern, cast off 4 sts at beg of next 2 rows. Decrease 1 st at each end of next 3 (4, 4, 5, 6) rows. Then decrease 1 st at each end of every alt. row until 77 (81, 85, 89, 91) sts remain. Continue straight until back measures 63 (64, 66, 67, 69)cm [25 (25¼, 26, 26½, 27)ins], with right side of work facing for next row.

Shape shoulders Cast off 7 (8, 8, 8, 8) sts at beg of next 2 rows. Cast of 8 (8, 8, 9, 9) sts at beg of next 2 rows. Then cast off 8 (8, 9, 9, 9) sts at beg of next 2 rows. Leave the

remaining 31 (33, 35, 37, 39) sts on a spare needle.

Left front
With 3¼mm needles and MS cast on 46 (46, 50, 54, 58) sts.

Work cable rib as back until it measures 8cm [3ins] with wrong side facing for next row.

Next row: Rib 2 (3, 1, 3, 1) [m1, rib 7 (5, 6, 8, 8)] 6 (8, 8, 6, 7) times, m1, rib 2 (3, 1, 3, 1). 53 (55, 59, 61, 65) sts.

Change to 4mm needles and joining in C, work the 22 rows of pattern from Chart B, working the 34 pattern sts once across, and working the first 9/10/12/13/15 sts and the last 10/11/13/14/16 sts on k rows, and the first 10/11/13/14/16 sts and the last 9/10/12/13/15 sts on p rows as indicated. Continue in this manner until front corresponds with back at armhole, with right side facing for next row.

Shape armhole Keeping continuity of pattern, cast off 4 sts at beg of next row. Decrease 1 st at armhole edge of next 3 (4, 4, 5, 6) rows. Then decrease 1 st at armhole edge of every alt. row until 39 (40, 43, 44, 46) sts remain. Continue straight until front measures 55 (56, 58, 59, 61)cm [22 (22¼, 23,

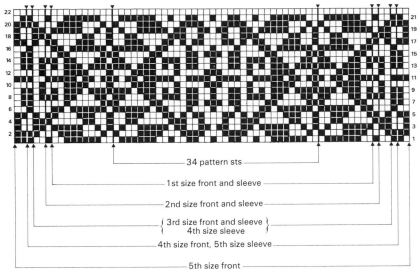

Key
As Chart A

34 pattern sts

1st size front and sleeve

2nd size front and sleeve

{ 3rd size front and sleeve }
4th size sleeve

4th size front, 5th size sleeve

5th size front

Chart B

$23\frac{1}{2}$, 24)ins], with wrong side of work facing for next row.

Shape neck Cast off 5 (5, 6, 6, 7) sts, work to end of row. Decrease 1 st at neck edge of every row until 23 (24, 25, 26) sts remain. Work straight until front corresponds with back at shoulder, with right side facing for next row.

Shape shoulder Cast off 7 (8, 8, 8, 8) sts at beg of row. Work 1 row.
Cast off 8 (8, 8, 9, 9) sts at beg of row. Work 1 row. Cast off remaining 8 (8, 9, 9, 9) sts.

Right front
As left but reversing all shapings.

Sleeves
With $3\frac{1}{4}$mm needles and MS cast on 46 (46, 50, 50, 54) sts. Work cable rib as back for 8cm [3ins] with wrong side facing for next row.
Next row: Rib 2 (3, 1, 1, 3) [m1, rib 7 (5, 6, 6, 8)] 6 (8, 8, 8, 6) times, m1, rib 2 (3, 1, 1, 3). 53 (55, 59, 59, 61) sts.
Change to 4mm needles and joining in C, work pattern from Chart B, working the 34 pattern sts once across, and working the first 9/10/12/12/13 sts and the last 10/11/13/

13/14 sts on k rows, and the first 10/11/ 13/13/14 sts and the last 9/10/12/12/13 sts on p rows as indicated. Increase 1 st at each end of every 5th row until there are 81 (83, 87, 89, 93) sts (working the increased sts into pattern). Continue straight until sleeve measures 43 (43, 44, 44, 44)cm [17 (17, $17\frac{1}{2}$, $17\frac{1}{2}$, $17\frac{1}{2}$)ins] from beg, and pattern row corresponds with back and front at armhole.

Shape top Cast off 4 sts at beg of next 2 rows. Then decrease 1 st at each end of every alt. row until 43 (45, 47, 45, 45) sts remain. Then decrease 1 st at each end of every row until 21 sts remain. Cast off.

Finishing
Omitting ribbing, press all pieces using a warm iron and damp cloth. Sew fronts to back at shoulder seams. Press.

Neck With right side of work facing, $3\frac{1}{4}$mm needles and MS, knit up 21 (22, 23, 24, 25) sts along right front neck edge, pick up and knit the 31 (33, 35, 37, 39) sts along back neck, then knit up 22 (23, 24, 25, 26) sts along left front neck edge. 74 (78, 82, 86, 90) sts. Work in cable rib as back for 12 rows. Cast off evenly in rib.

115

Button border With $3\frac{1}{4}$mm needles and
MS cast on 10 sts and work in cable rib until
border, when slightly stretched, fits up left
front to top of neck border. Sew in position
as you go along. Cast off evenly in rib.

Before working buttonhole border, mark
position of buttons on button border with
pins to ensure even spacing, then work
buttonholes to correspond.

Buttonhole border Work as for button
border with the addition of 9 buttonholes,
first to come 2cm [$\frac{3}{4}$in] above lower edge,
last to come 2cm [$\frac{3}{4}$in] below top of neck
border, remainder spaced evenly between.

To make buttonhole (Right side) p2, k2,
cast off 2, k2, p2.
Next row: k2, p2, cast on 2, p2, k2.

Join side and sleeve seams, insert sleeves.
Press seams and sew on buttons.

Estonia
Man's jacket

This pattern was inspired by the second band of the sock described on page 112. The band looks extremely Eastern, patterned in deep blue, brown and gold, with wine stripes. Again the design is geometric, but complex. I used it in its original colours on this shawl-collared man's jacket, the only change being that I used bouclé yarn for the wine shade.

Materials
4 (4, 5, 5, 6) 50g balls of Standard DK yarn in MS.
3 (4, 4, 5, 5) 50g balls of Standard DK yarn in 1st C.
3 (4, 4, 5, 5) 50g balls of Standard DK yarn in 2nd C.
2 (3, 3, 3, 3) 50g balls of DK weight bouclé yarn.
1 pair each $3\frac{1}{4}$mm, $3\frac{3}{4}$mm and 4mm needles.
5 buttons.

The yarn used in this garment is Hayfield 'Brig' DK and Hayfield Bouclé.

Measurements
To fit chest: 91 (97, 102, 107, 112)cm [36 (38, 40, 42, 44)ins]
Length from top of shoulder: 66 (69, 70, 71, 71)cm [26 (27, $27\frac{1}{2}$, 28, 28)ins]
Sleeve seam: 43 (44, 45, 45, 45)cm [17 ($17\frac{1}{2}$, 18, 18, 18)ins]

Tension
$11\frac{1}{2}$ sts and 13 rows to 5cm [2ins] measured over pattern using DK yarn and 4mm needles.

Back
With $3\frac{3}{4}$mm needles and bouclé, cast on 115 (121, 127, 133, 139) sts.

Knit 10 rows in garter st. Break off bouclé.

Change to 4mm needles and joining in and breaking off yarns, and changing to $3\frac{3}{4}$mm needles and garter st at bouclé stripe, work the 28 rows of pattern from Chart, repeating the 38 pattern sts 3 times across, and working the first 0/3/6/9/12 sts and the last 1/4/7/10/13 sts on k rows, and the first 1/4/7/10/13 sts and the last 0/3/6/9/12 sts on p rows as indicated.

Continue in this manner until back measures 43 (44, 45, 45, 45)cm [17 ($17\frac{1}{2}$, 18, 18, 18)ins] from beg, with right side facing for next row.

Shape armholes Keeping continuity of pattern, cast off 3 sts at beg of next 2 rows. Then decrease 1 st at each end of the next 3 (3, 3, 5, 5) rows. Work 1 row. Then decrease 1 st at each end of the next and every foll. alt. row until 91 (95, 99, 103, 107) sts remain.

Continue straight until back measures 66 (69, 70, 71, 71)cm [26 (27, $27\frac{1}{2}$, 28, 28)ins] from beg, with right side facing for next row.

Shape shoulders Cast off 8 (9, 9, 9, 10) sts at beg of next 4 rows. Then cast off 9 (8, 9,

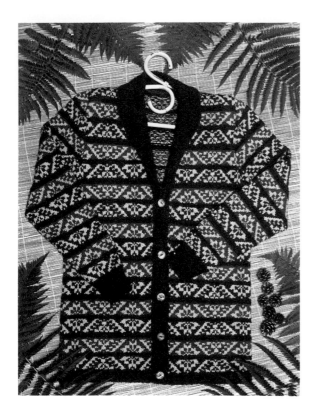

hole edge of the next 3 (3, 3, 5, 5) rows.

Work 1 row. Then decrease 1 st at armhole edge of the next and every foll. alt. row. *At the same time* decrease 1 st at neck edge of every 3rd row from 1st neck decrease, until 39 (41, 42, 44, 45) sts remain.

Then continue to decrease at neck edge *only* on every 3rd row, until 25 (26, 27, 28, 29) sts remain.

Continue straight until front corresponds with back at shoulder, with right side facing for next row.

Shape shoulder Cast off 8 (9, 9, 9, 10) sts at beg of next and foll. alt row. Then cast off the remaining 9 (8, 9, 10, 9) sts.

Right front
As left but reversing all shapings.

Sleeves
With 3¼mm needles and bouclé, cast on 50 (52, 54, 54, 58) sts.

k1, p1 rib for 8cm [3ins].

Next row: Rib 1 (2, 3, 3, 4) [m 1, rib 8 (6, 6, 4, 5)] 6 (8, 8, 12, 10) times, m1, rib 1 (2, 3, 3, 4). 57 (61, 63, 67, 69) sts.

Change to 4mm needles and joining in and breaking off yarns as required, work the pattern from Chart beginning at row 15. Work the 38 pattern sts once across, and work the edge sts as fronts.

Increase 1 st at each end of the 5th pattern row (row 19 of Chart) and every foll. 6th row until there are 85 (89, 93, 99, 103) sts (working increased sts into pattern).

Continue straight until pattern corresponds with back and front at armhole, and sleeve measures approx. 43 (44, 45, 45, 45)cm [17 (17½, 18, 18, 18)ins], with right side facing for next row.

Shape top Cast off 3 sts at beg of next 2 rows. Then decrease 1 st at each end of the next and every foll. alt. row until 45 (47, 49, 51, 53) sts remain. Then decrease 1 st at each end of every row until 21 sts remain. Cast off.

10, 9) sts at beg of next 2 rows. Cast off the remaining 41 (43, 45, 47, 49) sts firmly.

Left front
With 3¾mm needles and bouclé, cast on 57 (61, 63, 67, 69) sts.

Knit 10 rows in garter st. Break off bouclé.

Change to 4mm needles and joining in and breaking off yarns as required, work the 28 rows of pattern from Chart, working the 38 pattern sts once across, and working the first 9/11/12/14/15 sts and the last 10/12/13/15/16 sts on k rows, and the first 10/12/13/15/16 sts and the last 9/11/12/14/15 sts on p rows as indicated.

Continue in this manner until front corresponds with back at armhole edge, with right side facing for next row.

Shape armhole and neck edge Keeping continuity of pattern, cast off 3 sts, pattern to the last 2 sts, k2 tog.

Work 1 row. Then decrease 1 st at arm-

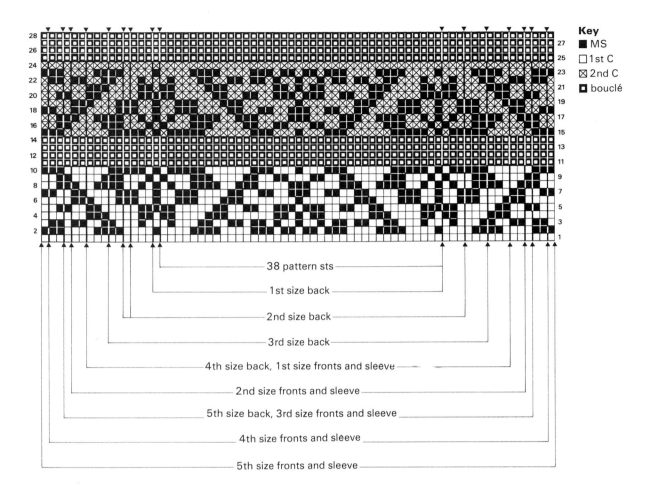

Key
- ■ MS
- □ 1st C
- ⊠ 2nd C
- ▣ bouclé

38 pattern sts

1st size back

2nd size back

3rd size back

4th size back, 1st size fronts and sleeve

2nd size fronts and sleeve

5th size back, 3rd size fronts and sleeve

4th size fronts and sleeve

5th size fronts and sleeve

Right front border and collar

With 3¾mm needles and bouclé, cast on 10 sts. Work in garter st until border, when slightly stretched, fits to first neck decrease. Then increase 1 st at beg of next row.

Continue, increasing 1 st on the same side of every foll. 3rd row until there are 30 sts.

Continue straight until collar, when slightly stretched, fits along to centre back of neck. Cast off evenly.

Left front border and collar

As right with the addition of 5 buttonholes, first to come 2cm [¾in] from hem, last to

come 2cm [¾in] below first collar increase, the remainder spaced evenly in between.

To make buttonhole Row 1: k4, cast off 2 sts, k4. Row 2: k4, cast on 2 sts, k4.

Finishing

Omitting collar, press all pieces using a warm iron and damp cloth.

Join back and fronts at shoulder seams and press. Attach front border/collar. Join collar sections at centre back. Press seams gently. Sew up side and sleeve seams and press. Insert sleeves. Press seams. Sew on buttons.

Astrakan
Child's all-in-one suit

The journey ends well inside the sphere of Eastern influence. A child's sock from Russia provided the inspiration for this all-in-one suit, and although little is known about its exact origins, there can be no doubt that they lie well and truly across the border. The sock is covered with an array of small geometric designs – squares, vertical and horizontal strokes, chequerboard and OXO patterns – worked in natural shades of gold, brown, yellow, orange and white. The individual elements are extremely simple, but because they are all packed in, with such a profusion of colour, the effect is rich and complex.

The suit uses all the features of the sock, both in colour and pattern, with simple designs on the body and OXO patterns on sleeves and yoke. White bouclé stripes between the OXO bands give just that slight, significant touch of Astrakan. This is a challenging project for any knitter, as the suit is knitted in one piece with constant shaping and colour changes. With its subtle, exotic flavour, it is bound to be noticed.

(See colour photograph opposite page 32.)

Materials
3 25g balls of Standard DK yarn in Bronze and Gold.
2 25g balls of Standard DK yarn in Ivory, Chocolate Brown and Wine.
1 25g ball of Standard DK yarn in Peach, Light Brown, and Khaki.
1 25g ball of DK weight bouclé yarn in Ivory.
1 pair each $3\frac{1}{4}$mm, $3\frac{3}{4}$mm and $4\frac{1}{2}$mm needles.
30.5 (36.5)cm [12 (14)ins] zip fastener.

Measurements
Age 1 to 2 (2 to 3) years.
To fit chest: 53 (56)cm [21 (22)ins]
Neck to crotch: 41 (46)cm [16 (18)ins]
Inside leg seam: 30 (35)cm [$11\frac{3}{4}$ ($13\frac{3}{4}$)ins]
Sleeve seam: 22 (24)cm [$8\frac{1}{2}$ ($9\frac{1}{2}$)ins]

Tension
12 sts and 12 rows to 5cm [2 ins] measured over Chart A pattern, using $4\frac{1}{2}$mm needles.

Legs

Back left leg With $3\frac{1}{4}$mm needles and wine, cast on 24 (26) sts.
k1, p1 rib in stripe sequence as follows:
4 rows wine/4 rows khaki/4 rows wine/3 rows khaki.
Break off wine and with khaki, increase as follows:
Rib 4 (m1, rib 1) 15 (17) times, m1, rib 5. 40 (44) sts.
Break off khaki. Change to $4\frac{1}{2}$mm needles, and joining in and breaking off colours as required, work the pattern from Chart A, repeating the 4 pattern sts 10 (11) times across.

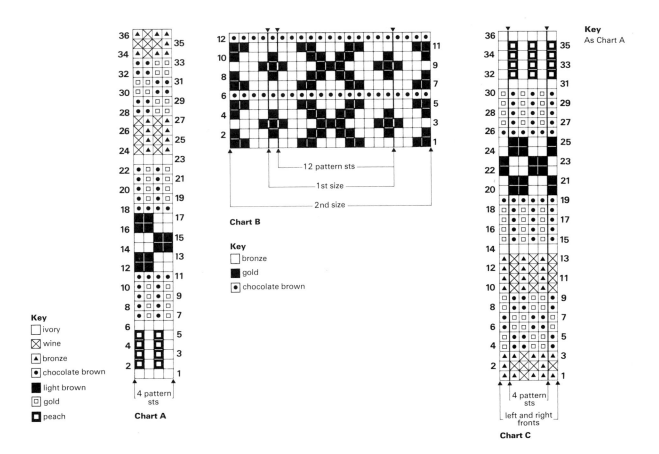

Chart B

Key
☐ bronze
■ gold
⊡ chocolate brown

Key
☐ ivory
⊠ wine
▲ bronze
⊡ chocolate brown
■ light brown
☐ gold
◼ peach

Chart A

Key
As Chart A

Chart C

4 pattern sts
left and right fronts

12 pattern sts
1st size
2nd size

4 pattern sts

Continue in this manner until leg measures 20 (23)cm [8 (9)ins] from beg, with right side facing for next row.

Keeping continuity of pattern, increase 1 st at beg of next and every foll. 4th row until there are 44 (48) sts.

Continue straight in pattern until leg measures 30 (35)cm [11¾ (13¾ins] from beg, with right side facing for next row.

Shape crotch Keeping continuity of pattern, cast off 2 sts, pattern to end of row. Work 1 row. Then decrease 1 st at beg of next and every foll. alt. row until 38 (42) sts remain.

Continue straight in pattern until piece measures 42 (49)cm [16½ (19¼)ins] from beg, with wrong side facing for next row. Leave these sts on a spare needle.

Back right leg As left but reversing all shapings (i.e. working leg and crotch

shapings on right edge of leg), and ending on the same pattern row as left leg, with right side facing for next row.

Join legs Keeping continuity of pattern, knit across the right leg, then pick up and knit the sts of left leg, pulling the yarn firmly between the last st of right leg and the first st of left leg. 76 (84) sts.

Continue straight in pattern until leg/back measures 53 (63)cm [21 (24¾)ins] from beg, with right side facing for next row. Break off yarns.

Sleeves/back yoke
Work as follows:

With 3¾mm needles and bouclé, cast on 35 (41) sts, then knit across the 76 (84) sts of back, then cast on 34 (40) sts. 145 (165) sts.

Work 3 (5) rows in reverse st.st. Break off bouclé.

Change to 4½mm needles and joining in

colours as required, work the 12 rows of pattern from Chart B, repeating the 12 pattern sts 12 (13) times across, and working the first 0/4 sts and the last 1/5 sts on k rows, and the first 1/5 and the last 0/4 sts on p rows as indicated.

Change to 3¾mm needles and bouclé, and work stripe as follows:

Knit 1 row. Work 3 (5) rows in reverse st.st. Break off bouclé.

(Chart B followed by bouclé stripe forms the yoke pattern.)

Change to 4½mm needles and joining in colours as required, work the first 8 rows of pattern from Chart B, as previously.

Right side
Next row: With right side facing and working row 9 of Chart B, pattern the first 60 (70) sts, place the remaining sts on a spare needle.

** Turn, and keeping continuity of pattern, and working Chart B/bouclé stripe sequence, shape right side as follows:

Pattern 3 rows straight. Then increase 1 st at the end (neck edge) of the next and every foll. alt. row until there are 63 (73) sts.

Then cast on 4 sts at beg (neck edge) of next row, pattern to end of row. Then cast on 5 sts at the end of next row. 72 (82) sts.

Continue straight (working the increased sts into pattern) and complete the 12 rows of Chart B. Change needles and work the bouclé stripe. Work the Chart B/bouclé stripe once again, ending with right side facing for next row. Cast off sleeve and work right front as follows:

With 3¾mm needles and bouclé, cast off the first 34 (40) sts. Break off bouclé.

Change to 4½mm needles and joining in colours as required, work the pattern from Chart C, *beginning the first row as last row of Back (Chart B)*, so that back and front pattern correspond when seamed. Repeat the 4 pattern sts 9 (10) times across, and working the first and last st on every row as indicated. Continue in this manner until front measures 20 (24)cm [8 (9½)ins] from beg of Chart C pattern, with right side facing for next row.

Increase 1 st at the end (crotch side) of the next and every foll. alt. row until there are 42 (46) sts (working increased sts into pattern).

Continue straight in pattern until front corresponds with back at crotch, with right side facing for next row.

Next row: Pattern to end, then cast on 2 sts. 44 (48) sts.

Continue straight in pattern for 5 rows. Then decrease 1 st at the end (inside leg) of the next and every foll. 4th row until 40 (44) sts remain. Then continue straight in pattern until front leg corresponds in length with back leg, and ending on the same pattern row. Break off colours.

Change to 3¾mm needles, join in khaki and decrease as follows:

k4 (k2 tog) 16 (18) times, k4. 24 (26) sts.

k1, p1 rib as follows:

3 rows khaki/4 rows wine/4 rows khaki/4 rows wine.

Cast off evenly.**

With right side facing, place the first 25 sts (back neck) from spare needle, onto a length of yarn. Then with 4½mm needles and joining in colours as required, pattern the remaining 60 (70) sts to end of row (row 9 Chart B).

Left side
Turn and work the left side as right from ** to **, reversing all shapings.

Finishing
Omitting ribbing, press the piece carefully using a warm iron and damp cloth.

Cuffs With 3¼mm needles and khaki, knit up 38 (40) sts along ends of sleeves.

k1, p1 rib in khaki/wine sequence as front legs. Cast off evenly.

Collar With right side facing, 3¼mm needles and khaki, knit up 18 sts along right front neck edge, pick up and knit the 25 sts from length of yarn and decrease 1 st at centre back, knit up 18 sts along left front neck edge. 60 sts.

k1, p1 rib in khaki/wine sequence as cuffs. Cast off loosely and evenly.

Front opening With 3¼mm needles, wine, and starting 8cm [3ins] up from crotch, knit up 54 (64) sts evenly along right front to neck edge, k1, p1 rib for 5 rows. Cast off evenly.

Making sure that pattern matches at all seams, sew up as follows:

Pin and sew up front seam, from crotch to beg of front rib.

Stitch bottom end of front opening to left front. Press seam and front rib gently. Insert zip, leaving front rib free to cover opening.

Pin and sew up back seam from crotch to waist. Press seam.

Pin and sew back to front along outside legs, up sides and along underarms and cuffs. Press seams.

Pin and sew up inside leg seams and press.

I hope that the diversity of the garments in this book has dispelled any myths about the 'sameness' of Scandinavian knitting. Although Scandinavia is a distinct unit, its borders face in opposing directions – both geographically and culturally. One looks outwards and westwards across a great ocean, the other eastwards to the interior of a vast continent. I hope that my designs reflect not only my own journey, but also the enormous variety of influences that inspired them.

Guide to techniques

Fair Isle

This technique uses two colours in the same row, stranding or weaving the yarn not in use across the back of the work. It is the method most commonly used in traditional Scandinavian knitting, and in most of the designs in this book. Some of the traditional patterns use more than two colours in one row. This generally creates a very bulky effect, but when worked carefully and in small areas it can give stunning results. The coat yoke for Suomi, Nomad, Chart B of Karelia and Chart A of Midnight Sun are all good examples.

Fig. 1. Stranding

Stranding This method is used when not more than 5 stitches are worked in one colour.

Holding the yarn in use with the right hand and the yarn not in use in the left hand, knit the required number of stitches in the first colour. Then carry the second colour *loosely*, across the back of the work, and knit the required number of stitches in this colour. (See fig.1.)

On purl rows, the colour not in use is carried across the front of the work.

Weaving It is advisable to use this method when more than 5 stitches are worked in one colour, as weaving avoids long strands on the back of the work, which may catch and break.

Hold the yarns as for the stranding method and work the first stitch. Then on the next and every following 3rd stitch, put

Fig. 2. Weaving

the point of the right hand needle into the stitch, then carry the yarn in the left hand over the top of the right hand needle and knit the stitch with the yarn in the right hand in the usual way, thus catching the yarn not in use without working it. (See fig.2.)

Weave the yarn in the same way on purl

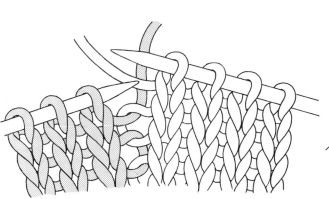

Fig. 3. Crossing yarns

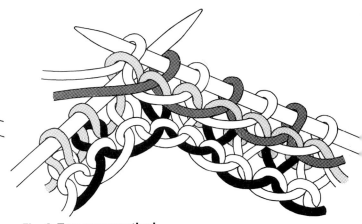

Fig. 4. Two yarns method

rows, across the front of the work, and weaving in on the first and every following 3rd stitch.

Jacquard

The Jacquard technique is used when the design consists of large areas in different colours. You use separate balls for each colour section, thus avoiding carrying the yarn across the back of the work. A fabric of single thickness is produced. When changing from one colour to another you must always cross the yarns, as follows.

To cross yarns: (right side rows) * knit the required number of stitches with the first colour, then hold this colour to the left, at the back of the work. Then pick up the second colour and carry it to the right at the back of the work, under and over the strand of the first colour. Then work the required stitches with the second colour. (See fig.3.)

Work the wrong side rows in the same manner, crossing the yarns at the front of the work.

The 'cross yarns' method is also used when working broad or single vertical stripes e.g. Midnight Sun and Nomad, on page 36 and 41.

Embroidery

This technique is often referred to as Swiss Darning, and is a useful method of adding small touches of colour, as in the Dalarna coat pattern on page 61.

Thread a tapestry needle with the contrast yarn and bring it through the work, from the

back so that it comes out on the right side, at the base of the first stitch to be covered.

Then * Insert the needle from right to left, under the 2 threads of the stitch immediately above the stitch to be covered. Then take it through to the wrong side at the base of the stitch being covered i.e. the starting point. Then bring it out at the base of the next stitch to be covered. Repeat from *

Two yarns method

This is an unusual technique, always worked in the round, which the Scandanavians used for knitting gloves and socks to wear in severe weather. The fabric produced is very dense and firm, which makes it ideal for working borders such as the one on the Halsingland dress, on page 68.

Cast on as for round knitting. Then using 2 balls of yarn (either the same or different colours), purl the first stitch with one yarn, * then carry this yarn in the left hand and hold it above the right hand needle, then purl the next stitch with the second yarn and repeat from *, thus intertwining the strands. (See fig.4.)

The knit row is worked in the same manner.

Finishing

Blocking and pressing Before pressing, check the instructions on the ball band (some man-made yarns should not be pressed).

If pressing is recommended, then each piece should be pinned out to size, right side

down, on a flat surface e.g. a large table or the floor covered with blankets and ironing sheet. Use plenty of pins (approx 4cm [1½ins] apart), and make sure that the stitches and rows are straight, and the side edges are not pulled out of shape.

Have the iron at the recommended heat (warm for wool), and place a piece of cloth (damp for wool) over the pinned out piece. Press the whole surface with an upwards downwards motion, i.e. lifting the iron up in the air, then placing it down on the knitting. Never use a sideways motion as this will stretch the knitting out of shape. Remove the cloth after pressing, and remove the pins when the piece has cooled.

Seaming Use the same or a finer matching yarn to make up the garment. For colour work use the predominant shade in the area being seamed. Use small, even stitches so that seams will not show, and make sure that the pattern matches at the seams. A fine backstitch is recommended for seaming colour work, and a loose, even catchstitch around necks and areas where a little 'give' is required. Press each seam as you go along.